HOUSE OF ETERNITY

The Tomb of
Nefertari

John K. McDonald

The Getty Conservation Institute
and the J. Paul Getty Museum
Los Angeles

Cover/title page:
Detail of Queen
Nefertari on the north
wall of Chamber G.

All photographs are
by Guillermo Aldana
unless credited
otherwise.

The Getty Conservation Institute works internationally to further
the appreciation and preservation of the world's cultural heritage
for the enrichment and use of present and future generations.

This is the first volume in the Conservation and Cultural Heritage
series, which aims to provide in a popular format information
about selected culturally significant sites throughout the world.

© 1996 The J. Paul Getty Trust
All rights reserved
Printed in Singapore

Library of Congress Cataloging-in-Publication Data

McDonald, John K.
 House of eternity: the tomb of Nefertari / John K. McDonald.
 p. cm.
 ISBN 0-89236-415-7
 1. Nefertari, Queen, consort of Rameses II, King of Egypt–Tomb.
 2. Mural painting and decoration, Egyptian. 3. Tombs–Egypt.
 4. Valley of the Queens (Egypt) I. Title.
 DT73.V34M35 1996
 932–dc20 96–24123
 CIP

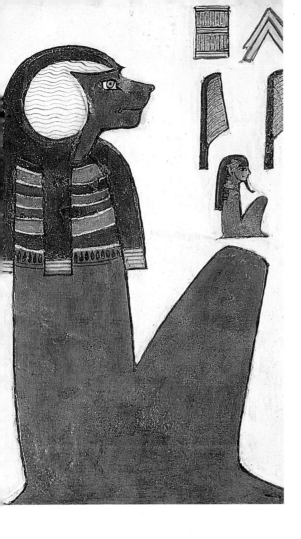

Contents

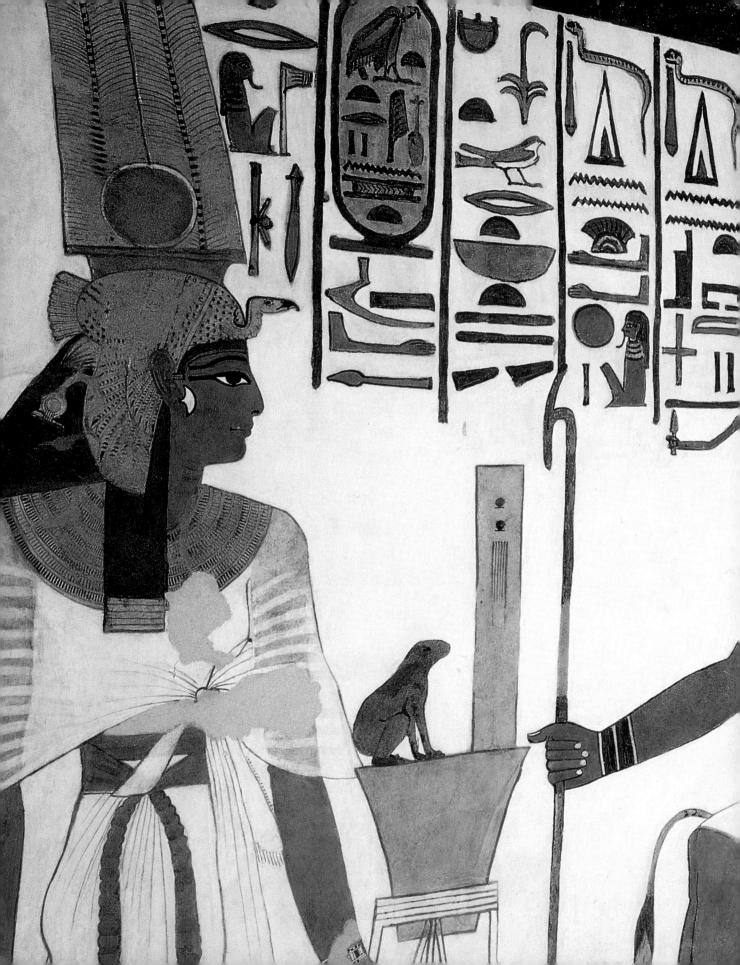

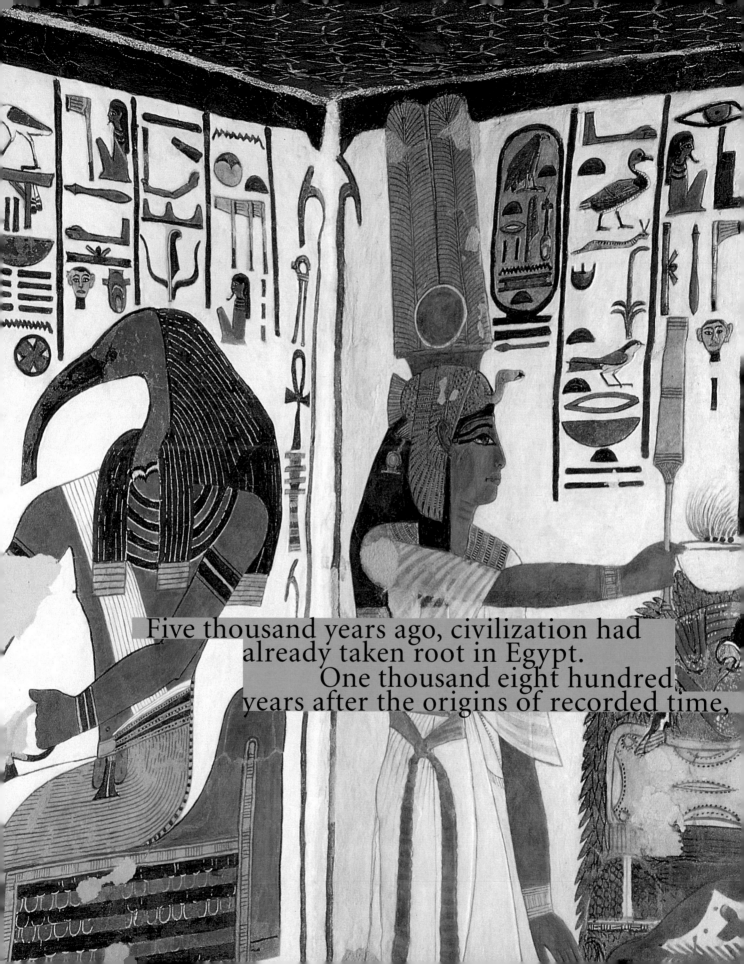

Five thousand years ago, civilization had
already taken root in Egypt.
One thousand eight hundred
years after the origins of recorded time,

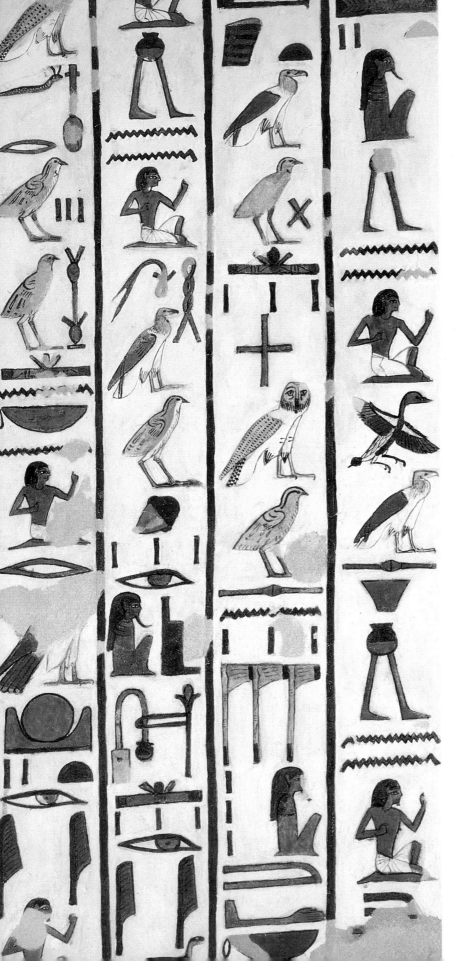

an honored and beloved queen, still in the prime of earthly existence, set off upon a voyage to the netherworld, in quest of eternal life.

In our own time, the art and culture of ancient Egypt have come to reflect the aesthetic imagination and spiritual aspirations of peoples everywhere. In Egypt, enduring yet endangered monuments embody some of the finest craftsmanship that has ever graced the planet.

The tomb of Nefertari, its brilliant images vividly depicting her voyage to the hereafter, ranks among the most precious and most fragile of Egyptian treasures, indeed of humanity. Moreover, it represents perhaps the most exquisite gift to be passed down through more than a hundred generations, a centerpiece of cultural heritage and a priceless patrimony of our time.

Yet ever since its modern discovery in 1904, the art in Nefertari's tomb—among the most beautiful examples of pharaonic wall paintings ever found—has been known to be in fragile and precarious condition. Consequently, for most of this time, the tomb has been closed to the public.

If the Nefertari paintings had continued to deteriorate, the world would have suffered an incalculable cultural loss. Instead, between 1986 and 1992, the

The last four columns of text behind Nefertari on the north wall of Chamber G. The inscription, which reads from right to left, is from Chapter 94 of the Book of the Dead.

Previous page: Sections of the north and east walls of Chamber G. On the left, Nefertari pays homage to Thoth, the god of writing. On the right, she makes offerings of incense, food, and cowhide.

Egyptian Antiquities Organization and the Getty Conservation Institute undertook an intensive collaborative effort to conserve the wall paintings in the queen's "house of eternity." This joint project proved exemplary in preserving for posterity one of the greatest treasures ever yet created by the human mind and hand.

In 1986, I was privileged to see the tomb for the first time. Like so many before me, I was both awed by the beauty of the paintings and appalled by the damage they had sustained. Ten years later, the ravages of time, nature, and humankind have been arrested. The surviving paintings have been rescued from destruction, with their historical integrity and authenticity intact.

Now, more than ever before, these marvelous paintings have a chance to survive for future generations. But only a chance. The tomb has been open to the public since November 1995. Consequently, in spite of all the painstaking conservation work, the paintings remain vulnerable.

Today, they stand as vibrant testimony to the creative genius of ancient Egyptian artists and as a celebration of art by an international community of policymakers and conservation professionals. Tomorrow, the paintings' survival will depend largely on the vigilant protection they receive in the years that lie ahead.

The mutual mandate of the renamed Egyptian Supreme Council of Antiquities and the Getty Conservation Institute will not be fulfilled until we succeed in generating broad awareness of the pressing problems facing endangered cultural properties worldwide. Solving these problems is not the exclusive privilege or responsibility of cultural, scientific, and political elites. It is rightly a matter of general public concern. Cultural treasures provide a record of our human condition on both a spiritual

and a material plane. To decipher this record is to know our past. And so, ourselves. To preserve it is to pass that knowledge on to future generations. In this sense, the tomb of Nefertari belongs to—and must be preserved by—all of us.

We have already learned that the public's interest in the tomb is remarkable. In 1992 the J. Paul Getty Museum and the Getty Conservation Institute organized an exhibition devoted to enhancing public awareness of the conservation problems and created a replica of one of the chambers. The exhibition, which subsequently traveled to Rome and Turin, proved to be a great success.

At the Getty Conservation Institute, our goal is to ensure that people everywhere come to recognize, appreciate, and acknowledge that the tomb of Nefertari and similarly rare and delicate works of art comprise precarious treasures of humanity. Paradoxically, they need to be protected above all from the risks of unrestrained exposure to those who admire them most.

In entering the tomb of Nefertari, you are about to experience a unique and sublime example of human creativity, in its aesthetic, material, and spiritual aspects. As we marvel at this priceless heirloom, let us find equally creative ways to provide not only public access to the treasures housed within the tomb, but also the means for their perpetual existence.

In this way, we may both respect the original intent of the creators and inspire future generations, as they too embark on our collective journey to the beyond.

Miguel Angel Corzo
Director
The Getty Conservation Institute

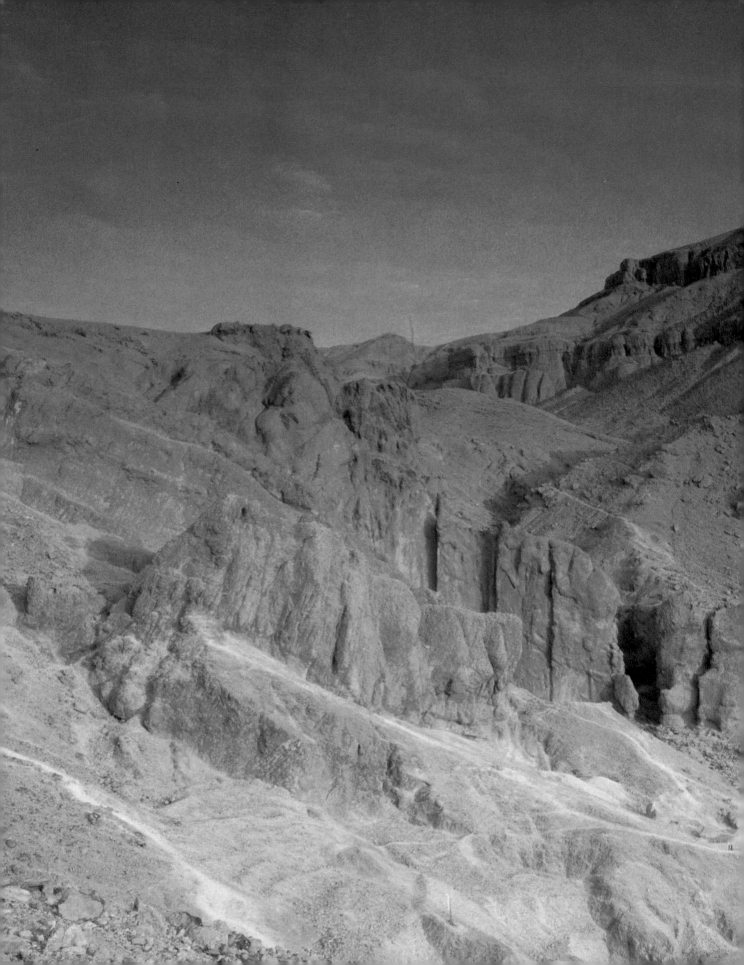

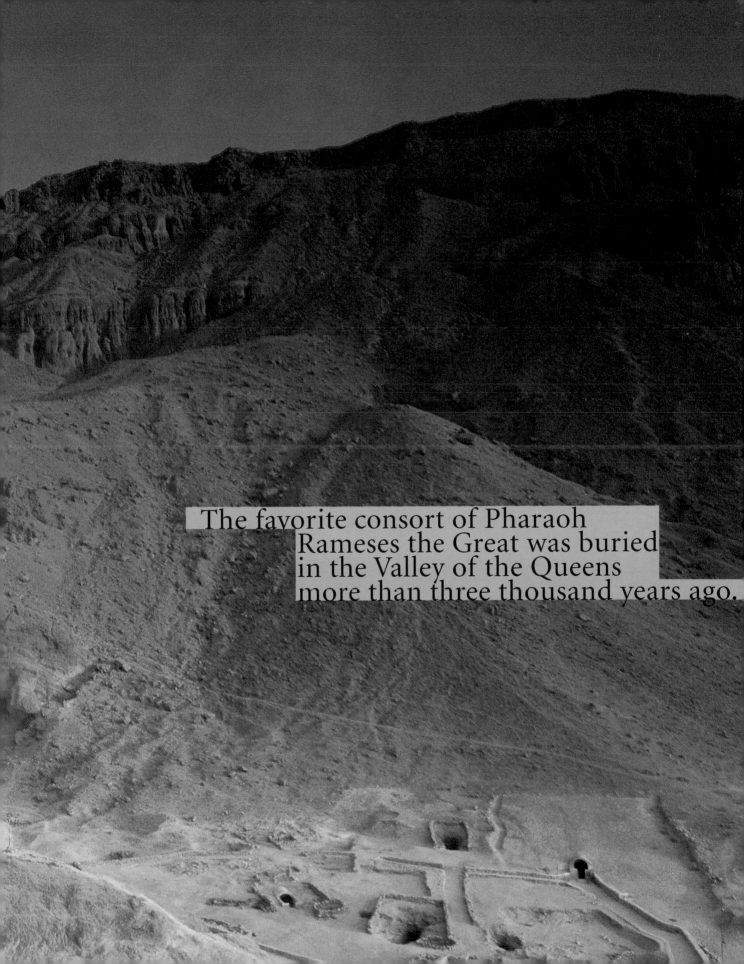

The favorite consort of Pharaoh
Rameses the Great was buried
in the Valley of the Queens
more than three thousand years ago.

Tunneled into the northern slope of the necropolis, Nefertari's

"house of eternity" is one of the finest tombs ever created by ancient Egypt's master craftsmen.

Emblazoned on its walls and corridors, some 520 square meters of exquisite wall paintings reveal a ritual process and illustrate Nefertari's journey of transformation into a blessed soul in the hereafter. It would prove a long and perilous passage; but she could rely on these hieroglyphic texts and illustrations to be her beacons to the beyond.

The Valley of the Queens is not renowned for the quality of its limestone. Indeed, like much of the rock in the Theban area, the limestone has been fractured by earthquakes and is banded with veins of flint. As a result, it is not well suited to painting or carving. Several layers of plaster had to be applied to the walls to build a suitable surface for the wall paintings. Vignettes and texts were lightly carved into the plaster when dry. The walls were then primed with a gypsum wash and painted in brilliant color.

The carved plaster in Nefertari's tomb is an early but sublimely successful instance of what was then a novel technique. The multitude of colors in her tomb is exceptional, especially the lighter ones, set off against the luxurious blacks and blue-whites.

Stereo view of the tomb entrance taken by Don Michele Pizzio/Francesco Ballerini, members of the Italian Mission led by Ernesto Schiaparelli in 1904.

Photo: Courtesy of the Museo Egizio, Turin.

Previous page:
The Valley of the Queens, across the river Nile from Luxor.

Opposite:
Detail from the south face of Pillar 1 in the sarcophagus chamber before conservation.

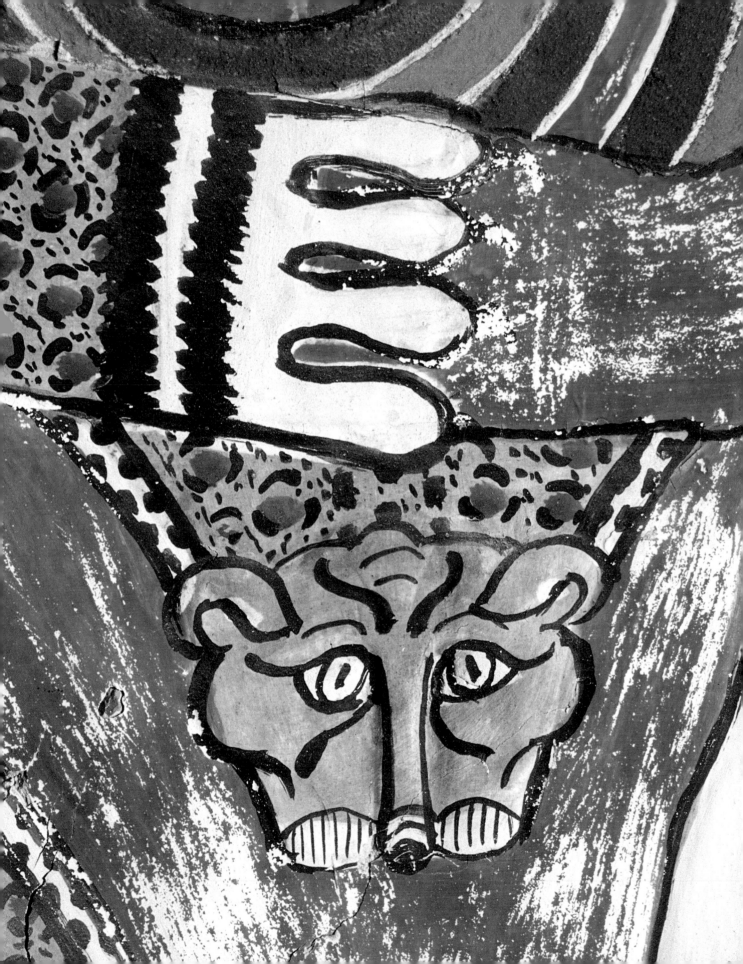

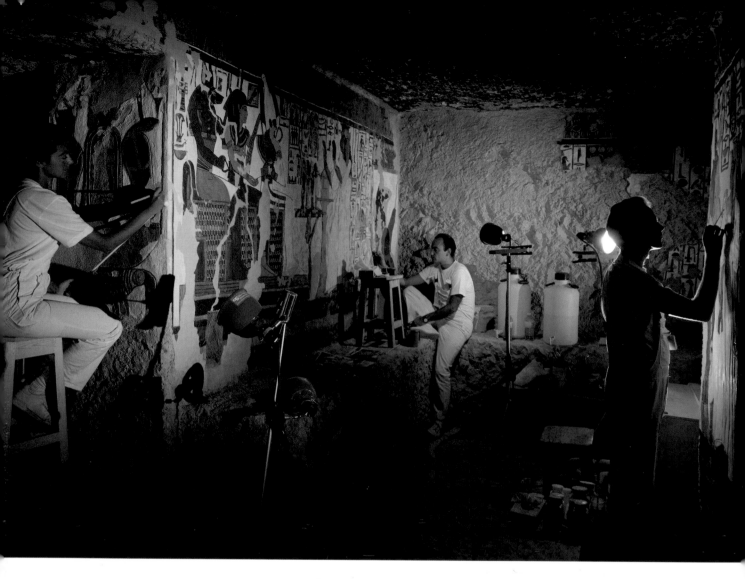

Conservators at work during final treatment on the northeast corner of Chamber K.

The theme of the tomb is timelessness: the decoration exclusively funerary. No references are made to any specific historic events or to anything that actually happened to Nefertari in her lifetime. Both aesthetically and spiritually, the transient concerns of this life are considered to be incompatible with eternity.

Similarly incompatible is the salt-laden nature of the limestone from which the tomb was hewn, as well as the Nile River mud used to plaster its walls. In the presence of moisture, salt, dormant in the rock and the plaster, migrated to the surface of the walls. Over time, fluctuations in humidity within the tomb, whether from the workmen who built it, subsequent flooding, seepage through fissures in the porous rock above, or perspiration and

respiration from contemporary visitors eager to view its marvels, have all served to mobilize the salt, bringing it to the painted surfaces, where it crystallized to damage and in some cases irretrievably destroy the art within the tomb.

To combat these dangers, the international team of conservators assembled in 1986 by the Getty Conservation Institute (GCI) and the Egyptian Antiquities Organization (EAO) undertook conservation of the tomb. First, emergency stabilization of detaching painted plaster; then meticulous conservation to preserve the tomb for present and future generations.

Nowhere in this process has "restoration" of the paintings been undertaken. Nor will it be. The GCI is philosophically committed never to engage in restoration,

believing that to restore an ancient work
by adding to it is inevitably to assault its
authenticity. In the tomb of Nefertari, not
a single drop of new paint was added to
the images. Similarly, all cleaning processes
and materials used in the conservation
were reversible.

The paintings that remain are in
every way authentic, entirely the work of
the original artists and artisans. They
have been carefully and respectfully con-
served, stabilized where in danger of
detachment, and cleaned of dirt and salt to
regain their original luster. Where the
original paintings have been lost, patches
of blank plaster (made from local, natural
products) now cover the walls.

Systematic, complex, laborious,
devoted, and respectful — such conserva-
tion work has much in common with the
journey undertaken by Nefertari in her
transition from this world to the next.
Within her "house of eternity," descending
stairways, asymmetries of design, and
the skewing of the tomb's axis are all
thought to allude to the tortuous topogra-
phy of the Egyptian netherworld. This
is the daunting domain that Nefertari
must traverse successfully in her search for
everlasting life.

DYNASTIES OF ANCIENT EGYPT

circa 3000 B.C.E.
 Late Predynastic Period
2920 – 2575
 Early Dynastic Period
 (*Dynasties I–II*)
2575 – 2134
 Old Kingdom
 (*Dynasties III–VIII*)
2134 – 2040
 First Intermediate
 Period
 (*Dynasties IX–XI/1*)
2040 – 1640
 Middle Kingdom
 (*Dynasties XI/2–XIII*)
1640 – 1532
 Second Intermediate
 Period
 (*Dynasties XIV–XVII*)

 New Kingdom
 (*Dynasty XVIII*)
* **1550 – 1525**
 Ahmose
1525 – 1504
 Amenhotep I
1504 – 1492
 Thutmoses I
1492 – 1479
 Thutmoses II
1479 – 1425
 Thutmoses III
1473 – 1458
 Hatshepsut
1427 – 1401
 Amenhotep II
1401 – 1391
 Thutmoses IV

1391 – 1353
 Amenhotep III
1353 – 1335
 Amenhotep IV/
 Akhenaten
1335 – 1333
 Smenkhkare
1333 – 1323
 Tutankhamun
1323 – 1319
 Ay
1319 – 1307
 Horemheb
 (*Dynasty XIX*)
1307 – 1306
 Rameses I
1306 – 1290
 Sety I
1290 – 1224
 Rameses II
 (The Great)
1224 – 1214
 Merneptah
1214 – 1204
 Sety II
1204 – 1198
 Siptah
1198 – 1196
 Twosre
1196 – 1070
 (*Dynasty XX*)
1070 – 712
 Third Intermediate
 Period
 (*Dynasties XXI–XXIV*)
712 – 332
 Late Period
 (*Dynasties XXV–XXXI*)
332 – 30 B.C.E.
 Macedonian–
 Ptolemaic Period
30 B.C.E. – C.E. 395
 Roman Period

** Dates given for individuals
represent regnal period.*

*Adapted from John Baines
and Jaromír Málek,*
Atlas of Ancient Egypt,
Oxford: 1980.

*One of two statues of
Rameses II on the façade of
the Temple of Hathor at
Abu Simbel.*

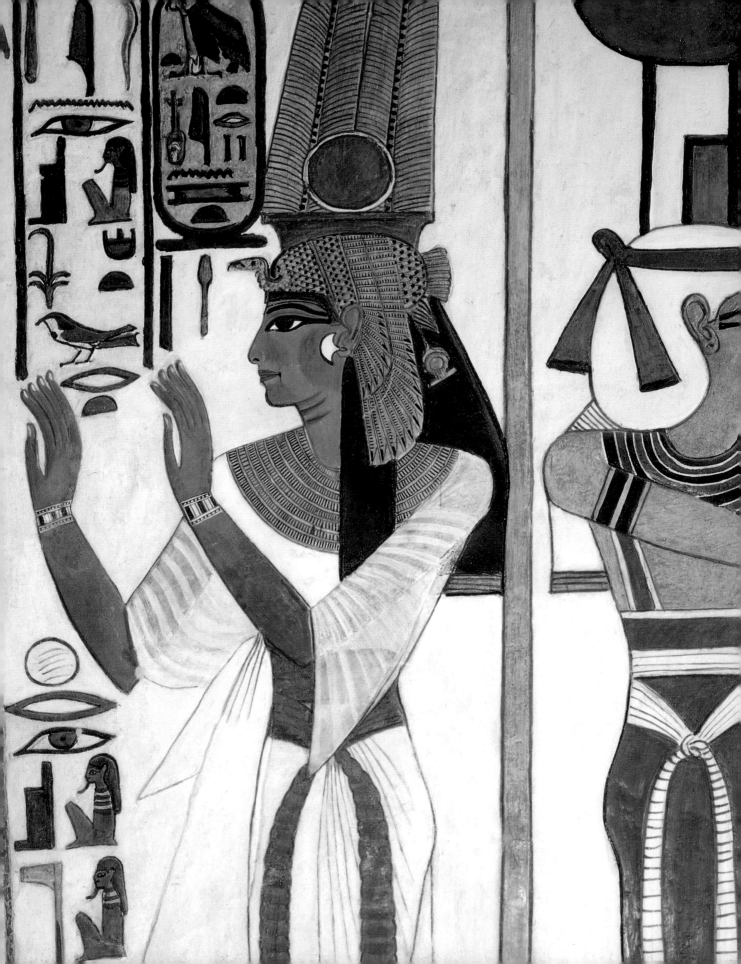

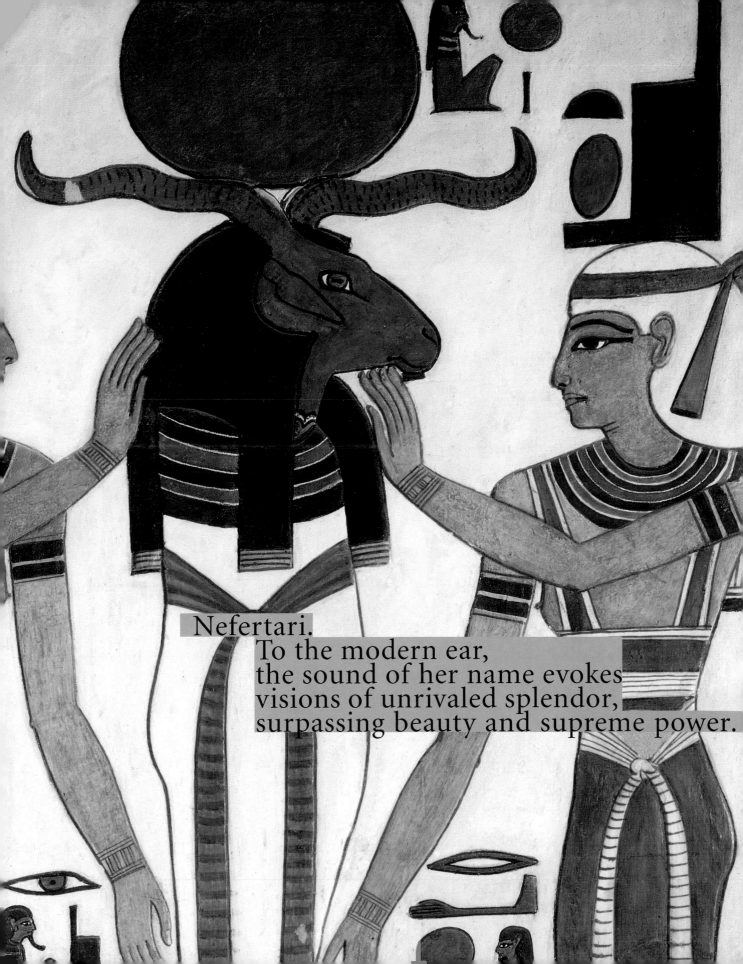

Nefertari.
To the modern ear,
the sound of her name evokes
visions of unrivaled splendor,
surpassing beauty and supreme power.

Why? Only because we have been blessed with brilliant images from her tomb in the Valley of the Queens.

If Nefertari's magnificent "house of eternity" had not survived, perhaps scholars of Egyptian history might still recognize her name. But could anyone even begin to imagine the elegant, dazzling young woman, the radiant being, we see so vividly portrayed throughout her tomb? With such evocative images enduring, no doubt remains that Nefertari was indeed the beautiful queen of one of history's most powerful and celebrated rulers, Rameses the Great.

What can historians tell us about the actual woman behind this compelling portrait? Certainly, Nefertari played important roles in state and religious affairs. Her importance was amply confirmed by her titles and the multiplicity of her images on monuments throughout Egypt: at the temples of Karnak and Luxor; in her tomb; and at a sandstone temple built at Abu Simbel, in far-distant Nubia, where her impact was literally colossal.

It is impossible to judge how much Nefertari's prestige was due to her personal qualities. It is also prudent to recall that she was by no means the first Egyptian queen to wield such power. Two of her predecessors—Ahmes-Nefertari and Nefertiti, wife of Akhenaten—figured prominently in the history of the New Kingdom. And the Eighteenth Dynasty King Hatshepsut was in fact a woman.

Detail of the colossus of Nefertari at the Temple of Luxor.

Previous page: On the west wall of Chamber G, south side, a band of relief separates Nefertari from Nephthys and Isis who flank the ram-headed god representing a union of Re' and Osiris.

Opposite: Nefertari on the east side of the upper descending corridor. The vignette differs from the correspond-ing west-side compo-sition in that here the queen's headdress is without the high plumes.

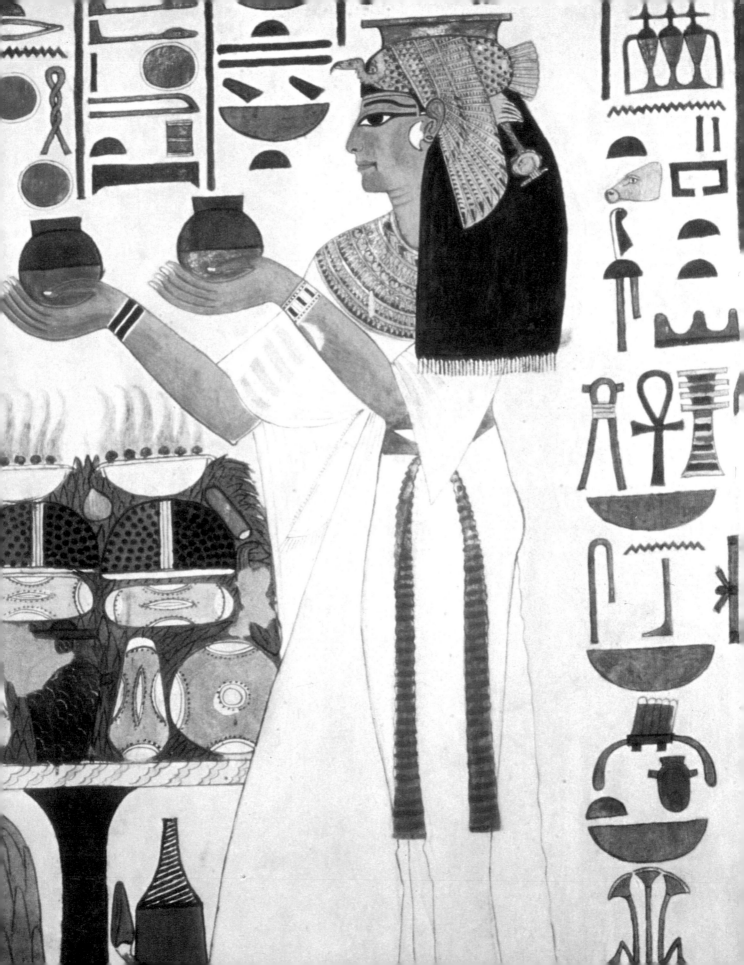

"Says Naptera [Nefertari], the great queen of Egypt to Padukhepa, the great queen of Hatti, my sister, thus. With you, my sister, may all be well, and with your country may all be well. Behold, I have noted that you, my sister, have written me enquiring after my well being. And you have written me about the matter of peace and brotherhood between the great king of Egypt and his brother, the great king of Hatti. May the sun god [of Egypt] and the storm god [of Hatti] bring you joy and may the sun god cause the peace to be good…. I in friendship and sisterly relation with the great queen [of Hatti] now and forever."

Nefertari's letter to Padukhepa, the Hittite queen, expresses her wishes for lasting peace. The Hittites were the Indo-European invaders of the Anatolian highlands. They established an empire during the course of the second millennium B.C.E. and challenged the supremacy of Egypt in the Middle East during the Eighteenth and Nineteenth Dynasties.

The relief on the inner face of the First Pylon at the Temple of Luxor. Nefertari, shaking a sacred rattle, is preceded by her husband, Rameses II.

The outline of Nefertari's life can be sketched. Of noble birth and perhaps from the Theban area, she was married, when barely a teenager, to User-maat-re' Setep-en-re', who was known to posterity as Rameses the Great. Their first-born child was a son, named Amenhirwenemef/Amenhirkhepeshef. Their eldest daughter was named Meryetamun.

Early in Rameses' reign, Nefertari took an active role alongside her husband: at Abydos, in Thebes, and at Gebel el-Silsila. Then came a long silence, unbroken until Year Twenty-one, when she suddenly reemerged at the signing of a peace treaty with Hatti, the other superpower of the times. Scarcely three years later, Nefertari died, was mourned, and was conveyed to her "house of eternity" in the Valley of the Queens. The year was 1255 B.C.E.

Images, inscriptions, and artifacts found in her tomb tell us more. Nefertari was of noble birth but not royal. Nowhere is she identified as king's daughter. Her family probably came from Thebes. Invariably, Nefertari's name was followed by "beloved of [the goddess] Mut." In the Theban area, Mut was an important deity. Together with her husband Amun-re' and their son Khonsu, she formed the sacred Theban triad of Karnak Temple. The consistent affiliation of Nefertari with Mut may point to the queen's Theban origins.

To her countrymen, Nefertari's name no doubt evoked a wealth of positive associations, above all with the memory of Ahmose-Nefertari, the founder of the Eighteenth Dynasty. As wife and sister of Pharaoh Ahmose and mother of Amenhotep I, Ahmose-Nefertari lived through the glorious days of Thebes' rise to power and her husband's expulsion of Asiatic invaders, the Hyksos, events occurring about 1560 B.C.E. It was probably intentional that Nefertari's chosen headdress—a vulture surmounted by double plumes—was also the headdress favored by Ahmose-Nefertari.

For Rameses to marry the daughter of a Theban nobleman would have been politically shrewd. The Ramesside clan was based in the Delta and had no blood ties with Egyptian royalty. Their rise to social prominence occurred through military service under Pharaoh Horemheb. Horemheb had no heir and designated his chief general, Parameses, as successor. When the old king died in 1307 B.C.E., Parameses assumed the throne, and changed the family name to Rameses, the name used by no less than eleven succeeding sovereigns.

Although Rameses I ruled only a year, he had time enough to inaugurate what Egyptian historians regard as a new era, the Nineteenth Dynasty. In a concerted effort to validate and legitimize Ramesside kingship, Rameses the Great, grandson of Rameses I, may well have sought a daughter of Thebes as his queen. Her given name recalled a resplendent moment in Egypt's history and her sobriquet invoked the Temple of Karnak, home of Egypt's first divine family.

In all likelihood, Nefertari married in her early teenage years and bore Rameses a son almost immediately. Together with his father, the boy was depicted as early as the first year of Rameses' reign, in the rock shrine of Beit el Wali in Nubia. Historians assume that Nefertari's firstborn child died young.

The queen's youth proved no impediment to her participating in religious and state business. Another depiction from Year One shows her officiating with the king at the investiture of the new Chief Prophet of Amun, Nebwenenef. This investiture was such a signal honor that Nebwenenef had the event memorialized on the walls of his own tomb.

Throughout his sixty-seven years of rule, Rameses took at least eight wives: Nefertari; Istnofret; Bintanath (his daughter by Istnofret); Meryetamun (his daughter by Nefertari); Nebtawy; Henetmire' (the king's own sister); Maat-Hor-Neferure' (the first Hittite princess); and a second Hittite princess. He fathered at least forty-five sons, perhaps as many as fifty-two, as well as some forty daughters.

As Rameses' first and favorite queen, Nefertari must have expected to see a child of hers inherit the throne. She is, after all, called "king's mother" in the great temple of Abu Simbel. Given her enormous importance, it is doubly ironic that Nefertari's children figure not at all in the succession. In fact, they all died prior to their father.

The enormous family catacomb that came to light in 1995 in the Valley of the Kings (KV5) may have been destined for the luckless, aging sons of Rameses II. Scattered throughout its more than ninety rooms are short inscriptions, at least one mentioning Nefertari's firstborn son, Amenhirwenemef/Amenhirkhepeshef. The catacomb is thus the likely place of his burial, along with scores of his half-brothers.

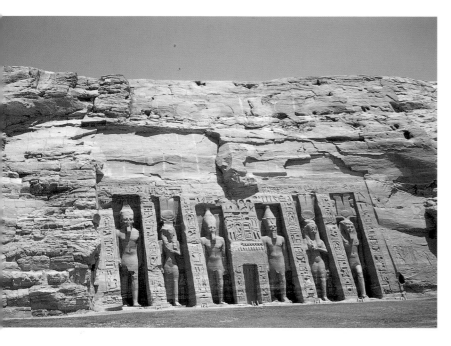

The façade of the small Temple of Hathor at Abu Simbel. On either side a colossus of Nefertari is flanked by colossi of Rameses II. Nefertari is crowned with the cow horns and sun disk symbolic of Hathor.

More evidence of Nefertari's role as religious officiant comes from the rock shrine of Gebel el-Silsila, where she was depicted "appeasing the gods." This portrayal of the queen was extraordinary, for making such offerings was a responsibility of kings, in their capacity as Chief Priest of Egypt. On the walls of Rameses' own mortuary temple in western Thebes, Nefertari was again shown taking part in an important religious holiday, the annual festival of the god Min.

Moreover, at Gebel el-Silsila, Nefertari was called "mistress of the two lands." Normal usage was for kings alone to be called lords of the two lands, a reference to the mythic union of the northern kingdom of Lower Egypt, the Delta where the Nile flows into the sea, with the southern kingdom of Upper Egypt, up river toward its headwaters. Applied to Nefertari, the phrase suggested that she exercised power in secular affairs.

In Year Three of Rameses' reign, Nefertari was shown beside the king in monumental scale on the interior face of the new pylon of Luxor Temple. Yet for a long while after that, no datable reference to the queen can be found.

In Year Twenty-one, however, Nefertari sent a letter to the distant capital of Hatti (modern Boghazköy) in Anatolia. With words of warmth and friendship, the queen sent her wishes for lasting peace to the Hittite queen, Padukhepa, on the occasion of the signing of a treaty between Rameses and the Hittite king, Hattushilis III. The treaty ended two decades of uneasy relations between their two countries.

At Abu Simbel in Nubia, on the Sudanese border, rises the great rock shrine of Rameses II. Beside it is the small temple of Hathor of Ibshak, dedicated to Nefertari. Here the queen is shown making offerings before a local form of the cow-goddess, Hathor, and Mut, Nefertari's patron. This in itself is impressive, but even more astonishing are the two enormous statues of the queen. On either side of the temple entrance stands a colossus of Nefertari, flanked by colossi of her husband. The two statues of the queen are every bit as large as those of Rameses. In the Egyptian artistic tradition, the scale of an image, whether in two or three dimensions, signifies its relative importance. Kings are made larger than their wives, children, courtiers, subjects, or enemies. For the queen to warrant a statue as large as her husband was an unparalleled honor.

The text on the temple façade is similarly remarkable, for it declares: "Rameses II has made a temple, excavated in the mountain of eternal workmanship in Nubia...for the king's great wife Nefertari, beloved of Mut, forever and ever,... Nefertari...for whom the sun does shine."

The great shrines at Abu Simbel were dedicated three years after the Hittite treaty, in the twenty-fourth year of Rameses' reign. Yet Nefertari, noticeably absent from memorials of these consecration ceremonies, had probably already died.

A number of rock inscriptions set into the cliff face around the temples recorded the events. One of these inscriptions, by the Viceroy Hekanakht, includes a picture of the royal entourage: Rameses was shown not with Nefertari but rather with his daughter Meryetamun, now identified as queen.

We cannot say how Nefertari died. All that is known is that, sometime toward the end of her fourth decade, she began her journey to the hereafter.

Transported to the netherworld by the magnificent tomb that Rameses had built for her, she would henceforth dwell in a new domain, a resplendent "house of eternity." For Rameses, it would be another forty years before he would pass through the portals of his own tomb, perhaps anticipating renewed union with the blessed spirit of his beauteous, beloved wife.

The titles and epithets of Nefertari define her various roles as divine consort, queen, and mother. The scope of her activities is consistent with the expanding importance of queenship in the New Kingdom generally.

"[The one] to whom beauty pertains" is one of several translations of her name. Ancient Egyptian hieroglyphic script does not show vowels, so no one can be certain how the queen's name was spoken.

Cuneiform script documents from the Hittite capital of Bogazköy in Anatolia suggest the name was pronounced "Naptera" or something similar.

"Beloved of Mut" is a standard component of Nefertari's full name and occurs even within her cartouche, the oval ring surrounding royal names. The goddess Mut, together with her husband Amun and their son Khonsu, form the great Theban triad of gods residing within or near Karnak Temple.

"King's great wife" identifies Nefertari as preeminent among Rameses the Great's eight known spouses.

THE QUEEN'S TITLES AND EPITHETS

"Mother of the king" is the title held by the crown prince's mother, confirming that one of Nefertari's sons had already been picked to succeed Rameses.

"God's wife," a term first encountered early in the Eighteenth Dynasty but falling into disuse after the reign of Thutmoses IV (1401–1391 B.C.E.). It is revived in the Nineteenth Dynasty in association with the dynasty's first three queens: Sat-re, wife of Rameses I; Mut-tuy, wife of Sety I; and Nefertari. The term was probably resurrected partly to strengthen the dynastic claims of the Ramesside kings, who were not of royal blood. It embodied a theological concept. Any child of a queen bearing this title was the issue not only of the king but also of the god Amun, the queen's mythical consort; and so, the child would be singularly fit to serve as king of Egypt.

"Hereditary noblewoman" is an honorific designation signaling that Nefertari came from noble stock.

"Mistress of the two lands." The masculine form is an epithet of Egyptian kings and proclaims their suzerainty over both Upper and Lower Egypt. It indicates that Nefertari exercised some role in state affairs.

"Mistress of Upper and Lower Egypt." This term may also hint at an active role in state affairs.

"Who satisfies the gods" is a phrase normally reserved for kings, in their role as Chief Ritualist.

"For whom the sun shines" (inscription from the façade of the Small Temple at Abu Simbel) is unique. In conjunction with the Great Temple of Abu Simbel, any invocation of the sun—either its disk (the Aten) or the sun god (Re')—is appropriate. The Great Temple of Abu Simbel was purposely orientated so that rays from the rising sun would shine straight into the sanctuary on February 22 and again October 22.

"Great of favors" possibly carried a judicial implication, along the lines of intercessor. That is how the term was used much earlier, in the popular Egyptian tale of the wanderings of Sinuhe.

"Pleasant in the twin plumes" (on the great seated statue of Rameses, now in the Museo Egizio, Turin) is a reference to the twin-plumed headdress favored by Nefertari. The god Amun wears a similar crown; one of his titles is "he of the high plumes." Nefertari's namesake, Ahmose-Nefertari, is often shown wearing a double-plumed headdress.

The great cemeteries
of ancient Thebes lie
across the Nile from
the modern town of Luxor and

beyond the broad swath of cultivation between the river and the Libyan plateau.

The plateau is a vast desert region that extends westward from the Nile more than a thousand miles. Made of fossil-rich limestone laid down by incursions of ancient seas, it stretches from magnificent cliffs formed over millennia by the meanderings of the river. Innumerable bays and canyons have been etched by wind, sand,

and the thermal stress of hot days and cold nights. Such forces of nature broke down the rock still more into scree that now rings the bases of the cliffs. In this desolate region lie the world-famous cemeteries of western Thebes: the Valley of the Kings, the Tombs of the Nobles, and the Valley of the Queens.

Placing their cemeteries to the west was instinctive for the ancient Egyptians, who localized the netherworld in the land of the setting sun. This association took on particular meaning in Thebes because

Previous page:
A view across the
river Nile toward
western Thebes.

The main wadi in the
Valley of the Queens
showing some of
the tombs of queens
and royal children.
Nefertari's tomb is
indicated. Photo: A. Siliotti.

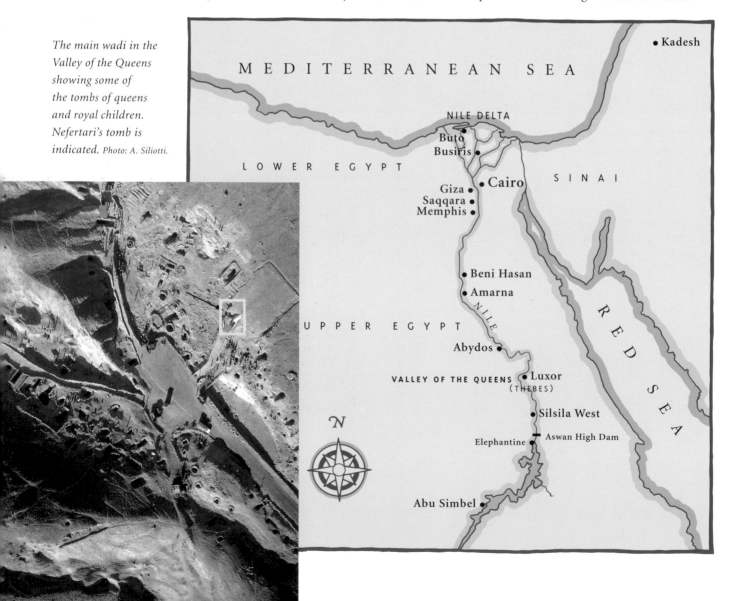

of the great western peak of Qurna, by far the most prominent landmark around.

From its summit, one can look down into the Valley of the Kings or east across the cultivation to the river. Beyond the Nile, barely visible through the haze, are the pylons of Luxor Temple. Along the edge of cultivation stands a row of mortuary temples. The largest of these, Medinet Habu, was erected to the memory of Rameses III.

Just behind this temple, an asphalt road follows an ancient track and wends its way back to the peak, running near the workmen's village of Deir el-Medineh. After passing a rock-cut shrine to the god Ptah, another to the local goddess Meret-Seger, and the ruins of a Coptic monastery, the road peters out in a small valley directly beneath the peak of Qurna. This is the Valley of the Queens.

At its western limit is a gorge. In front of that are vestiges of an ancient dam that once diverted runoff from sudden cloudbursts. Signs of wind and water erosion abound. Weathered chunks of limestone and flint litter the ground. Finer material washed down to the valley floor has softened the contours. Suggestions of rude huts made from tabular limestone are all that remain of the shelters used by the workmen who excavated the tombs in the Valley of the Queens.

It's unclear precisely why this area was selected for burials. Though vulnerable and hard to police, its chief virtue may have been convenience. But certainly the looming mass of Qurna and its divine associations with the beyond would have appealed to the ancient Egyptians. It is also possible that the gorge suggested to them the vulva of the sky goddess Nut, depicted in tombs and coffins giving birth to the sun god each morning.

ERNESTO SCHIAPARELLI

Italian Egyptologist Ernesto Schiaparelli (1856–1928) began his studies with Francesco Rossi at the University of Turin, and continued them in Paris between 1877 and 1880 with the great French Egyptologist, Gaston Maspero. For many years, Schiaparelli was director of the Egyptian Museum in Turin.

As head of the Italian Archaeological Mission to Egypt between 1903 and 1920, Schiaparelli also explored numerous Egyptian sites. His most enduring achievements were in the vicinity of Thebes — in the workmen's village at Deir el-Medineh and in the Valley of the Queens.

In 1906, while working at Deir el-Medineh, Schiaparelli discovered the undisturbed burial of Khai, an overseer of works, and his wife Meryt. The abundant household materials from their tomb, now on display in Turin, provide a detailed picture of life among the workmen who dug and decorated Egyptian royal tombs.

In 1904, Schiaparelli opened Nefertari's tomb, one of thirteen that he cleared or discovered in the Valley of the Queens. Though he spent only a year in the tomb, Schiaparelli compiled an important photographic record of its condition and decoration. These 135 glass plate negatives — housed in the Turin Museum — have served as a benchmark ever since.

Schiaparelli and his assistant Francesco Ballerini assigned numbers to all the tombs in the valley, installed iron gates at their entrances, and pioneered site management by laying out pathways between the tombs. The arched, brick portal that now protects the entrance to Nefertari's tomb was also built by the Italian mission.

Ernesto Schiaparelli published a volume on his work in the Valley of the Queens in 1924. A second volume, on his explorations at Deir el-Medineh, was published in 1927, a year before his death.

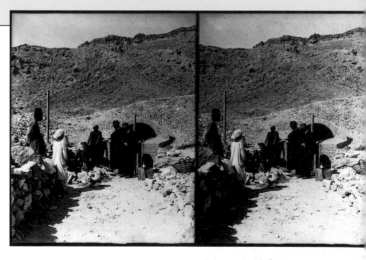

Stereo view of Ernesto Schiaparelli (far right) at the entrance to the tomb of Nefertari after construction of the brick portal.

Photo: Courtesy of the Museo Egizio, Turin.

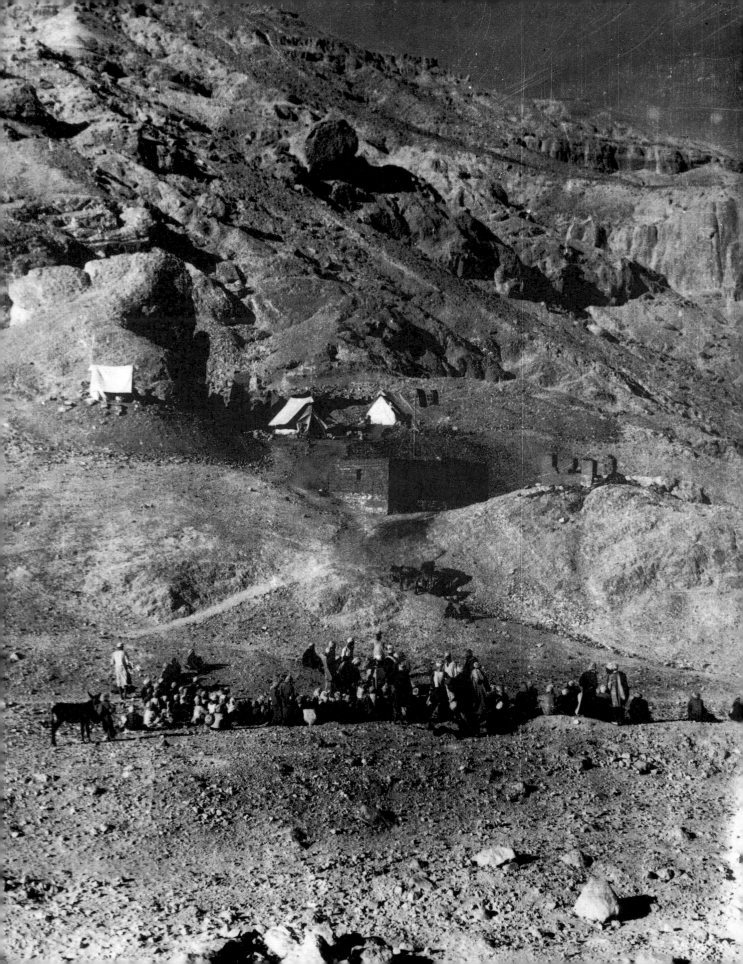

An ephemeral stream surging down the gorge might have reinforced this image of sacred issue.

There are eighty numbered tombs in the Valley of the Queens. Only twenty are decorated. Most are little more than pit tombs, without decoration or inscription. The larger openings of the more substantial tombs probably suggested the common Arabic name for this site: "Biban el Malikat" or "the Portals of the Queens."

The most ancient of these large tombs date from the Eighteenth Dynasty and were private or anonymous. But early in the Nineteenth Dynasty, it became the fashion to bury queens and royal children in this lonely valley. Throughout the next two centuries, many important members of the court found their final resting place here. Along the northern flank of the valley are tombs of the queens and daughters of Rameses II; along the southern flank, the sons of Rameses III.

The ancient Egyptians initially referred to this locale as simply "the Great Valley." But after the surge in royal inter-ments — queens, dowager queens, and children — it became known as "the place of the beauteous ones."

Archaeology has confirmed what the texts say. Most of the burials in this valley are royal. They include those of three very important queens from the early years of the Nineteenth Dynasty: Sat-re, wife of Rameses I; Mut-tuy, wife of Sety I; and, of course, Nefertari, favorite consort of Rameses II.

Why was this place reserved for queens? Several explanations come to mind. Most likely is that Hatshepsut had a tomb prepared for herself in a neighboring canyon before she became pharaoh, and the three foreign-born wives of Thutmoses III were interred not far away.

The designation "Valley of the Queens" was introduced by Jean François Champollion in the nineteenth century C.E., then taken up by other Egyptologists. The first Europeans to explore the site were J. G. Wilkinson (1821–33), Champollion (1828–29), Ippolito Rosellini (1834), and C.-R. Lepsius (1845). Lepsius correctly identified the tomb of Meryetamun, Nefertari's eldest daughter, but missed locating the queen's, just adjacent. That honor fell to Ernesto Schiaparelli, who explored the valley between 1903 and 1904. For this and his efforts at the workmen's village, Schiaparelli earned himself a last-ing place in the annals of Egyptology.

Opposite:
The camp site of
Ernesto Schiaparelli's
expedition in the
foothills of the Valley
of the Queens, 1904.

Photo: Courtesy of the
Museo Egizio, Turin.

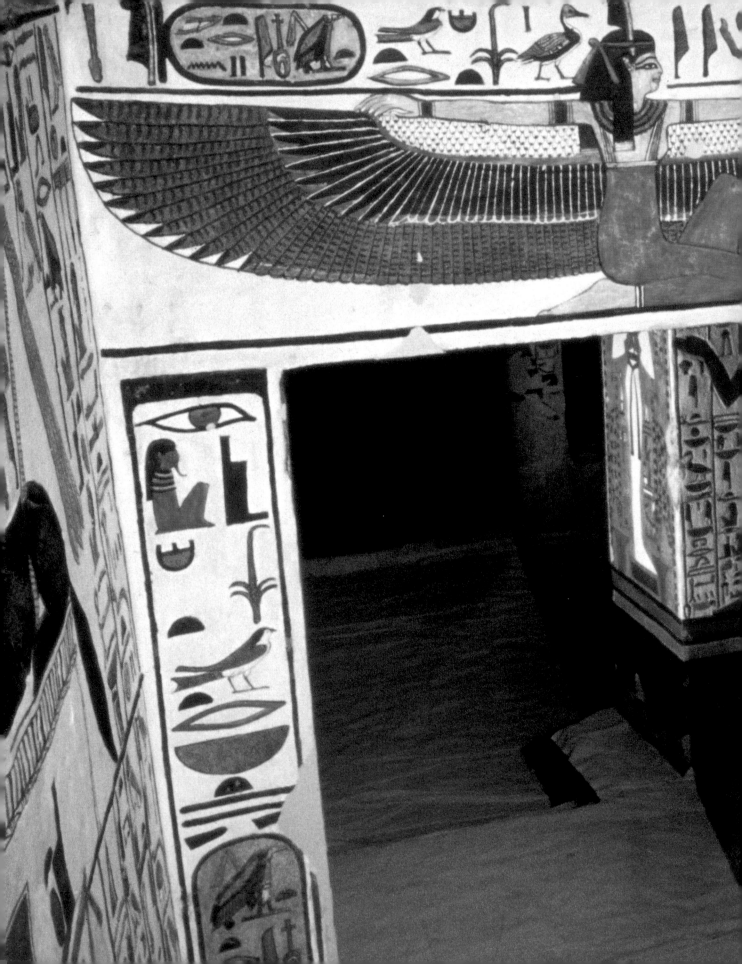

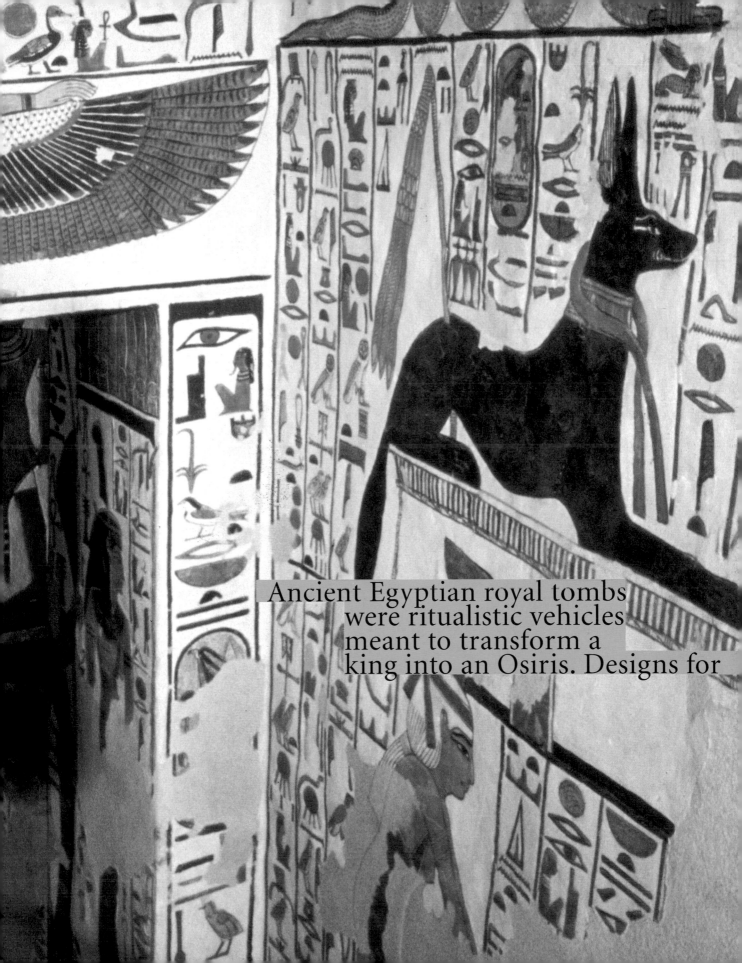

Ancient Egyptian royal tombs were ritualistic vehicles meant to transform a king into an Osiris. Designs for

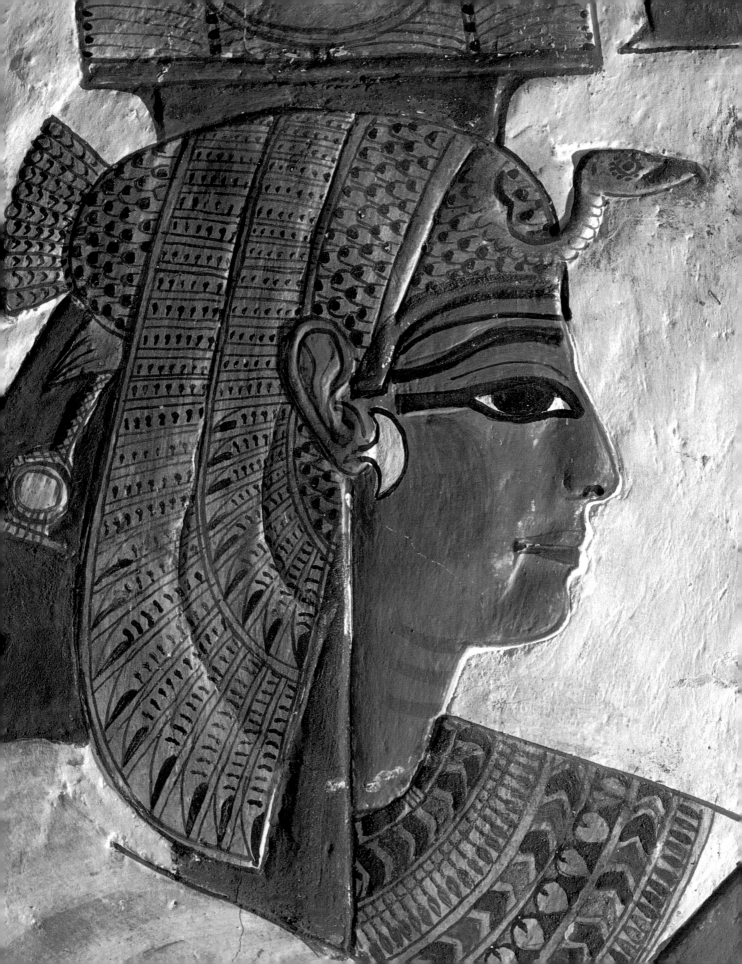

royal tombs were probably drawn up by court architects, with the king's involvement.

Yet no one knows exactly how the sovereign expressed his wishes for the tomb's location, size, and decoration.

During the Old and Middle Kingdoms, they took the form of pyramids. There are some seventy such pyramids in the Nile valley. During the New Kingdom, royal tombs underwent fundamental redesign ultimately evolving into a pencil-thin shaft, sunk obliquely into the hillsides of the Valley of the Kings. Beginning with the pharaoh Thutmoses I (1504–1492 B.C.E.) and for five centuries afterward, Egyptian sovereigns ordered their tombs excavated in this remote canyon.

New Kingdom tomb design at first consisted of a series of descending corridors, small waiting rooms, and then a sarcophagus hall with annexes. These elements were usually assembled in the repeating pattern of corridor followed by chamber, corridor followed by chamber: a rhythm of down-pause, down-pause.

This design accomplished two aims. First, it reminded the Egyptians of the "crookedness of the beyond." For the tomb was meant to evoke the twisted topography of the netherworld. Turns and plunging stairways imitated the convoluted path that the deceased had to follow to become an effective, blessed soul. Second, the doubling of the basic unit — down-pause, down-pause — may have alluded to the traditional division of Egypt into northern and southern kingdoms, or have suggested the duality of earthly versus timeless existence.

Detail of Nefertari's face on the west wall of the descending corridor showing the painted correction to the relief work.

Previous spread: Looking into the burial chamber from the descending corridor. The goddess Ma'at, with outstretched wings, adorns the lintel.

Opposite: The head of Nefertari on the west wall of the descending corridor showing carved relief work.

Detail from the north wall of Recess E illustrating a correction in the painting.

A simple, painted wall primed with whitewash had been the standard in the tombs of the early Eighteenth Dynasty. Carved limestone was not introduced until the reign of Horemheb (1319–1307 B.C.E.), but was then immediately adopted as the standard in royal tombs. Carved plaster imitating limestone made its appearance about this time — most sublimely in Nefertari's tomb — and remained a feature of Ramesside tomb decoration.

The overall design of Nefertari's tomb borrows from the architecture of contemporary royal tombs. It also reflects the increasing religiosity that pervades Ramesside tomb decoration.

For his own tomb, Rameses the Great reintroduced a sharp ninety-degree turn just before the burial chamber and increased the number of its supporting pillars around the sunken sarcophagus emplacement to eight. A shelf around the perimeter of the burial hall was a feature repeated from Nefertari's tomb. In strictly architectural terms, Rameses' tomb remains the most complex and interesting in the Valley of the Kings.

From Rameses' death forward, Egyptian royal tombs underwent immense simplification, especially in their ground plans. The tomb of Merneptah, Rameses' immediate successor, stressed length over annexes and chambers, which began to diminish in size or vanish altogether. The descending stairway was replaced by a shallow, continuous ramp leading deep into the mountainside.

The logical conclusion of these trends was the tomb of Rameses VI: long, straight, spare. Its decoration also showed evolution characteristic of the later Ramesside era: illustration and text were drawn in outline, with a minimum of modeling or internal detail. The many colors of

Nefertari's tomb were replaced by predomi-
nantly golden hues to reinforce solar imagery.

A royal tomb's design could not be
turned over to the workmen until a site was
selected. This task proved increasingly
difficult as the royal valleys became filled
with burial sites. In some instances, architects
chose unwisely, siting their work where
it eventually intersected older tombs and so
had to be abandoned or modified.

Once construction had begun, many
steps in the work — from cutting to smooth-
ing to decorating — may have gone on simul-
taneously, heavy work preceding lighter.
Quarrymen first opened the shaft by ham-
mering the porous rock with heavy mauls.
They then removed the shattered pieces with
chisels and adzes. All such heavy-duty tools
were provided by the state and rigorously

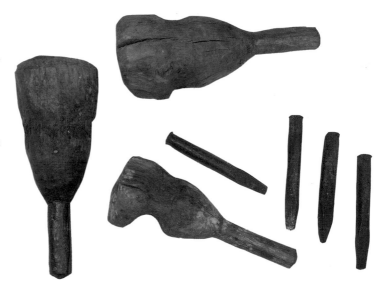

*Hammers and chisels
used in the construc-
tion of royal tombs.*
Photo: J. Hyde.

*Detail from the east
side of the south wall
of the upper corridor
showing uncorrected
overlapping paint.*

accounted for. Tailings from the cutting were dumped right outside the tomb, a convenient but untidy practice. However, this custom had at least one happy consequence. The entrance to the tomb of Tutankhamun was buried beneath an avalanche of rock from the excavation of Rameses vi's tomb. Had it not been, the boy king's tomb might have been found and looted long ago.

As work progressed into the selected hillside, an army of artisans followed at the quarrymen's heels. Masons rough-leveled the walls using a boning rod (a primitive sighting gauge consisting of two flat rods connected by twine) and ensured that walls were vertical by means of a plumb bob. Imperfections, such as flint nodules, were either left in place or removed, as the situation warranted. Any large holes or weak pockets of rock were plugged with mortar made of crushed limestone and gypsum. Smooth-leveling was probably achieved by abrasion. Once this stage was complete, the walls were primed with a gypsum wash.

With the walls prepared, apprentice draftsmen could begin drawing both illustration and text. Working first in red, they outlined hieroglyphic text and images that were subsequently corrected and adjusted in black by master draftsmen, exactly the reverse of the Western artistic custom. Guided by these outlines, sculptors then carved and scoured away the background so that the designs stood out in relief.

Painters and varnishers came last, carefully painting over the carved design, sometimes making inspired deviations that improved upon the composition. Details too fine to execute in rock or plaster were liberally supplied in paint. The completely self-assured brushwork of these artists has given a fresh and spontaneous effect to many scenes throughout the Theban necropolis.

Some tombs were constructed in distinct stages, with long intervals between successive trades plying their crafts. Yet when time was short — as it likely was in the case of Nefertari — there is reason to believe that quarrymen, plasterers, outline draftsmen, carvers, and painters all worked at the same time. Under these conditions, parts of the tomb were completed from the inside out, the squads of workmen eventually finishing up back at the entrance where they began.

Workers seem to have maintained "left" and "right" crews, each performing two four-hour shifts a day. At night, they camped out in huts midway between the tomb and their village, on a ridge beneath the peak of Qurna. Their "weeks" lasted ten days, eight days of labor and two days off back in the village.

Besides the tools provided by the state, other materials and supplies had to be brought daily to the site. Food and water were essential to sustain the men; but water was also required for painting and plastering. Critical lighting was provided by shallow pottery saucers that burned oil or animal fat mixed with salt to reduce smoke. Wicks for these lamps were made of twisted flax and were supplied by the state. Like the tools, these wicks were strictly rationed.

Ceiling detail showing black underpainting.

TOMB PAINTS AND MATERIALS

Paints used in Nefertari's tomb consisted of pigment for color, water to make the paint flow, and gum to bind it to the surface of the wall. The Egyptian palette was limited to vivid, primary colors. Only a handful of words for these colors existed, and none captured the nuances between shades of the same hue.

Egyptian pigments were mineral, not organic. Earth colors — reds and yellows — were made from burnt umber, cooked iron oxide. Shades of red resulted from trace amounts of manganese, while yellow was prepared from a hydrated iron oxide or ochre. Blues and greens were compounded from natural copper ores: malachite or azurite. Occasionally, these ores were cooked with calcium and quartz or other forms of silica, producing a glass that was then pulverized.

Blue and green pigments tended not to adhere well to the wall surface and consequently show more damage today. The black in Nefertari's tomb was powdered charcoal. It too could be easily brushed off. Whites were made of chalk (calcium carbonate) or gypsum (calcium sulphide) or some blend of the two.

The binder was gum arabic, derived from the local acacia tree. Unlike egg tempera, which becomes insoluble over time, gum arabic can redissolve under certain conditions and is damaged by ultra violet radiation. Thus, if the paint in Nefertari's tomb were to become damp enough, it could "flow."

Surface coatings in the tomb consist of tree resin and egg white (albumen). Employed chiefly as a glaze on red and yellow areas, they enhance the brilliance of the color beneath. But since resin and albumen have always been readily available, no one knows if these coatings are original or, if not, when they were applied.

Detail of impasto paint.

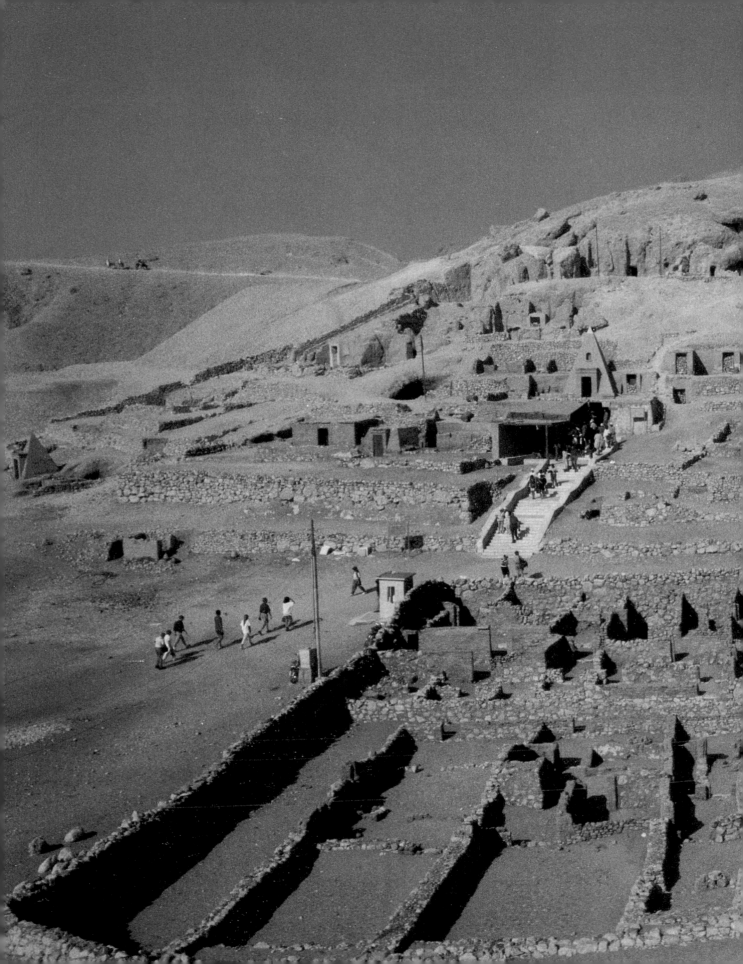

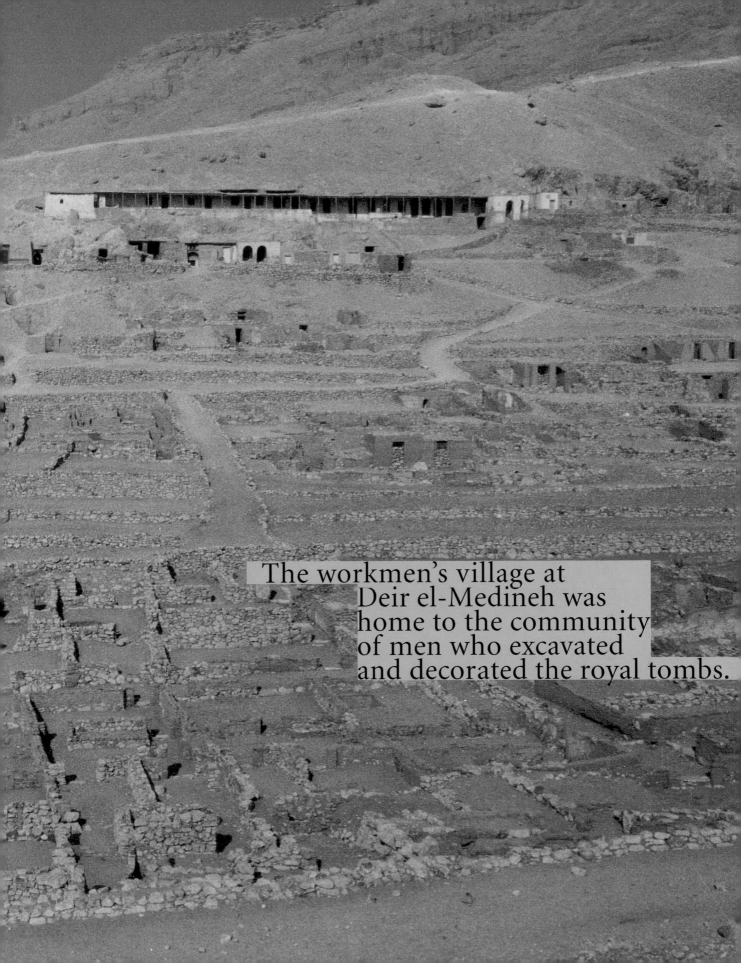

The workmen's village at Deir el-Medineh was home to the community of men who excavated and decorated the royal tombs.

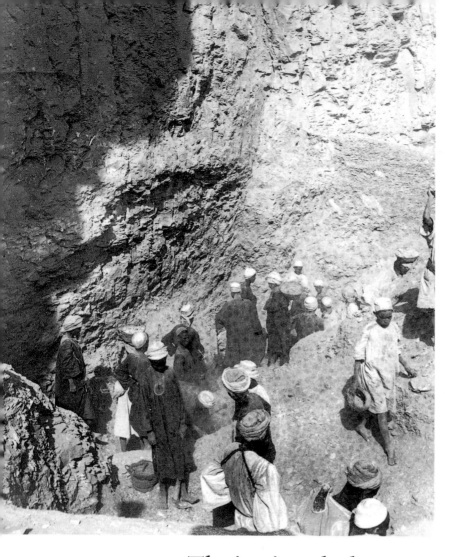

Workmen excavating in the Theban necropolis during the expedition of the Italian Archaeological Mission led by Ernesto Schiaparelli in 1904.
Photo: Courtesy of the Museo Egizio, Turin.

Previous page: The community of the pharaoh's tomb builders at Deir el-Medineh.
Photo: C. Leblanc.

Their simple homes were made of limestone and flint.

Each house had an entryway leading to a living room, which was often provided with a built-in sleeping couch. This was the only piece of fixed furniture. Behind were a tiny room and an unroofed kitchen, with oven and silos beyond. Stairs made of a notched palm trunk led to the roof, used for storage and sleeping in hot weather. Some houses also had a tiny storage cellar beneath the living room floor.

The community was founded early in the Eighteenth Dynasty by Thutmoses I, the first pharaoh to dig a sepulcher in the Valley of the Kings. The settlement grew, but not steadily. The Amarna period, when the court was resident in middle Egypt, could not have been a prosperous time for the village. But it was reinvigorated and reorganized during the reign of Horemheb, who enclosed the settlement and organized the workmen into crews. Under Rameses II the community consisted of perhaps 48 men and their families, but reached its zenith in the reign of Rameses IV, when the population peaked at about 120 families.

Much of what we know of the village comes from tens of thousands of inscribed limestone flakes on which the workmen recorded their daily affairs. These, the paper of ancient Egypt, summarize important matters such as law suits and divine oracles. But they are also filled with the mundane. They chronicle the revictualing of the village, tell us when the men were sick or shiftless, speak of marital problems, and hint at drunkenness. They describe what other jobs the workmen performed and what they did on holidays, feast days, and occasional days off. We can even reconstruct the genealogies and fortunes of thirteen families and so form a picture of life in a community that enjoyed work, prayer, and leisure.

The workmen spent their entire careers as privileged state employees. When not digging in the necropolis they stayed in the community and when they died, they were buried in tombs of their own making, in the hillside just opposite the village. Two of these were discovered intact with their full complement of funerary equipment: the tomb of Sennedjem in 1885 and that of Khai in 1906.

The men of the community were known as "servitors in the place of truth," a reference to the royal tombs in the Valley of the Kings. The men were organized into teams known as "gangs," modeled after a ship's crew. The most important members of the community were the foremen of the gangs, followed closely by the scribes. The foreman functioned as chief of works and had a deputy to distribute tools and collect them again at the end of each shift. The scribe functioned as director of personnel, recording workers' attendance and calculating their pay.

Originally, these village captains were appointed by the vizier, the king's chief minister. But in the Ramesside age, the positions became hereditary; dynasties of scribes and foremen over five and six generations were not uncommon.

The men were trained as stone masons, draftsmen, carvers, carpenters, and painters, all skills acquired from fathers and passed down to sons. Wages varied according to rank; but everyone was paid in kind: grain, oil, and beer drawn from state storehouses. Supplementing these were disbursements of fish, vegetables, water, pottery, and fuel.

Estimates of the value of wages suggest that the workmen had enough left over to barter for durable goods or luxury items not readily available inside their compound. They even undertook contract work on each other's tombs, helped out on state projects outside the necropolis, and perhaps invested some free time in private projects not sanctioned by the state. It is conceivable that some of these men worked on the Tombs of the Nobles, not far away.

With the workmen spending most of their time on state-funded projects or engaged in occasional "freelance" work, they had to rely on a staff of water carriers, fuel porters, victualers, and provisioners of all sorts to supply many of their essential needs.

After repeated attacks by bandits sweeping down out of the western desert, Deir el-Medineh was abandoned in the early Twenty-first Dynasty (1070–945 B.C.E.). The community of workmen was relocated to the safety of Medineh Habu, the mortuary temple of Rameses III.

In any event, the industry of royal tomb construction was now all the more literally a dying business. Tombs might yet be constructed for the Theban priesthood, but the kings of the Twenty-first Dynasty, who resided in distant Tanis, preferred burial in the temple enclosure there rather than in Thebes with its hallowed valleys of the kings and queens.

Recently restored dwellings of the workmen in the Valley of the Queens.
Photo: A. Siliotti.

Example of limestone flakes inscribed with daily events in the workmen's lives.
Photo: J. Hyde.

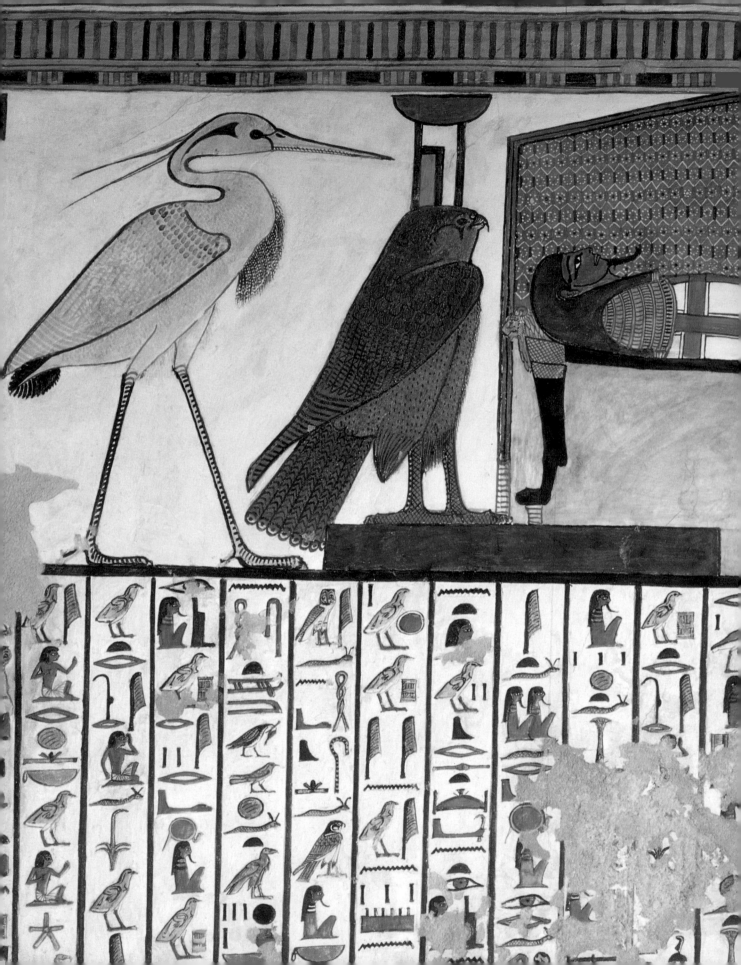

Some fifty to seventy years after
the death of Nefertari,
during the Twentieth
Dynasty, Egypt experienced

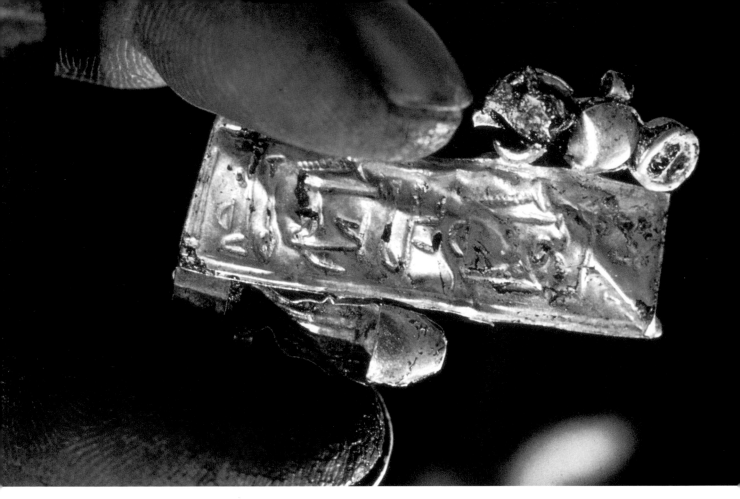

A piece of embossed gold foil bearing Nefertari's name and an epithet "true of voice" discovered in 1988 by one of the tomb's conservators.

Previous page: The upper west wall of Chamber C. Nefertari, masked and mummified lies on a bier with the goddesses Nephthys and Isis in their kite form at her head and feet. Next to Nephthys is the benu bird, associated with resurrection. Beside Isis is a water god symbolizing abundance of years.

several severe economic depressions, brought on in part by the loss of gold mines and deteriorating relations with allies in the Near East. For an economy based on precious metal, the loss of the mines amounted to a financial catastrophe.

Sit-down strikes by the necropolis workers in Thebes occurred in the twenty-ninth year of Rameses III (about 1165 B.C.E.). Workmen laid down their tools and marched to the Ramesseum, the mortuary temple of Rameses the Great, seeking back wages. The disputed payments consisted mostly of grain and oil, which the workmen had ample reason to believe were sequestered in huge, mud-brick storehouses that today still stand behind the temple. Despite assurances from government officials, the back wages did not materialize until the workmen called a second strike, one involving their wives and children.

Not surprisingly under such circumstances, a cottage industry in tomb robbery arose. Apart from its spiritual function, the necropolis was a vast treasure trove of liquid wealth just waiting to be pillaged. All one had to do was muster the courage to break into a tomb and strip the mummies of their gold and jewels.

The situation became acute during the reign of Rameses IX (1125–1107 B.C.E.). In the sixteenth year of his reign, there was a rash of tomb robberies. Court proceedings preserve the testimony of people who knew about or had participated in the looting. Charges were hurled against local officials and even the mayor of western Thebes who were accused of conniving with workmen to rob tombs.

A generation later, the situation had grown even worse. The Theban priests of the Twenty-first Dynasty (1070–945 B.C.E.) were so alarmed that they gathered whatever royal mummies they could locate and secured them in places of safety. Two such caches have been discovered, one in the tomb of Amenhotep II in the Valley of the Kings, and a second in an Eleventh-Dynasty tomb belonging to a minor queen named In-hapy.

Neither sign nor mention of Nefertari's mummy has been found apart from some telltale fragments of her remains, discovered by Schiaparelli in 1904. Considering the extreme vulnerability of the tombs in the Valley of the Queens, it seems likely that Nefertari's tomb was robbed as long ago as 1109 B.C.E.; yet no one can know what took place inside the tomb for some three thousand years.

In addition to the mummy fragments, Schiaparelli discovered that the tomb still held pieces of the queen's rose granite sarcophagus, thirty-four servant figurines (*ushabtis,* believed to be essential for the deceased to become an Osiris), several large glazed earthenware vases, and an enamel knob bearing the name of King Ay.

In 1904, some items of the queen's personal jewelry appeared on the antiquities market in Luxor and were purchased by the Museum of Fine Arts, Boston. These included a large plaque of gilded silver, a small plaque made of embossed sheet gold, a gilded bronze pendant in the shape of a lily, and four servant figurines. Although the exact origin of this jewelry is unknown, there is every reason to suppose it was part of the queen's burial equipment.

Astonishingly, in 1988, while trying to reattach a section of wall plaster, one of the tomb's conservators discovered a piece of embossed gold foil. The ornament bore Nefertari's name and the epithet "true of voice." The title is a customary designation for a deceased person and a strong indicator that the bracelet was made expressly for the great queen's burial.

Nefertari's sandals were among the few objects that escaped looting. Photo: J. Hyde.

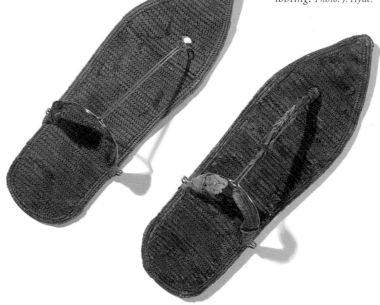

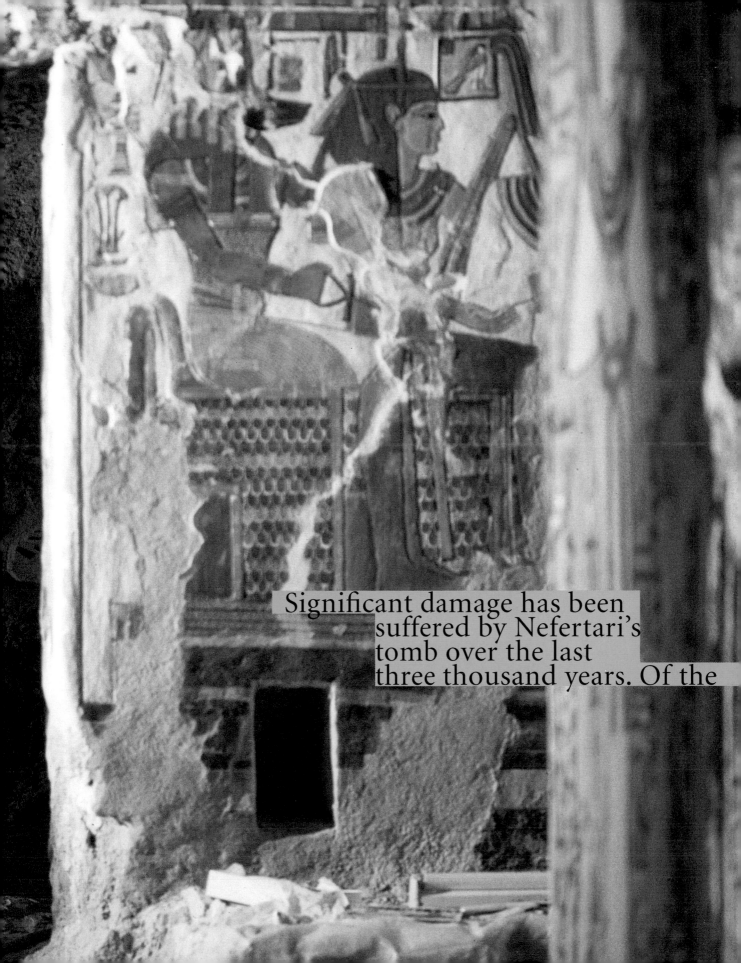

Significant damage has been suffered by Nefertari's tomb over the last three thousand years. Of the

A conservator working on the south wall of Recess E in 1988.

Opposite:
The goddess Isis in Recess E, north wall, showing a few of the nearly ten thousand Japanese mulberry bark paper bandages used to hold loose fragments in place during emergency conservation.

Previous page:
Removing ground dust during site preparation in 1988 in Chamber Q.

tomb's 520 square meters of original paintings and hieroglyphic decoration, at least twenty percent has completely vanished.

Since its discovery in 1904, the archaeological community has known of the perils facing the tomb and its matchless decoration. Even Schiaparelli had to perform emergency consolidation on sections of wall paintings during his initial survey. Yet despite his and others' efforts to solve some of the tomb's most tenacious problems, the deterioration continued, much of it the result of carelessness by visitors.

With this in mind, in 1985, the Egyptian Antiquities Organization (EAO) — renamed the Egyptian Supreme Council of Antiquities in 1994 — and the Getty Conservation Institute (GCI) began discussions to see how the tomb's paintings might be consolidated and cleaned, and further deterioration arrested or at least slowed. A joint EAO-GCI project was established in 1986.

Initial plans called for a full year's analysis of the tomb's geological, hydrological, climatic, and microbial problems, as well as exhaustive testing of plaster, pigments, and other materials. Preliminary results confirmed suspicions that the primary culprit responsible for the deterioration was salt. The limestone of the tomb and the mud plaster coating with which the walls had been finished were affected by moisture. As a result, minute amounts of sodium chloride dormant in the limestone and plaster were dissolving. Once mobilized, this salt-laden moisture seeped to the surface of the wall. There the moisture evaporated, leaving the salt behind, as crystals either within the plaster or as a crust upon the paint.

Salt crystals lodged between the limestone and the plaster can detach entire sheets of plaster. Smaller crystals within the plaster layers can split whole layers off the painted surface. The crust on the paint itself can all too easily be brushed away, and with it a good deal of pigment. Any increase in moisture within the tomb or sustained high humidity will affect the plaster and painting adversely.

The basic problem has been too much moisture from four sources: water used in the original preparation of plaster and paint; flooding via the tomb entrance; seepage through the porous limestone; and water vapor, introduced mainly by modern-day visitors.

Flooding has been a constant risk. The ancient dam at the head of the valley gorge proves how seriously Necropolis officials took this threat. Thick layers of water-transported debris in the Valley of the Kings and the Valley of the Queens have been dated from the Nineteenth Dynasty and testify to serious flooding in ancient times.

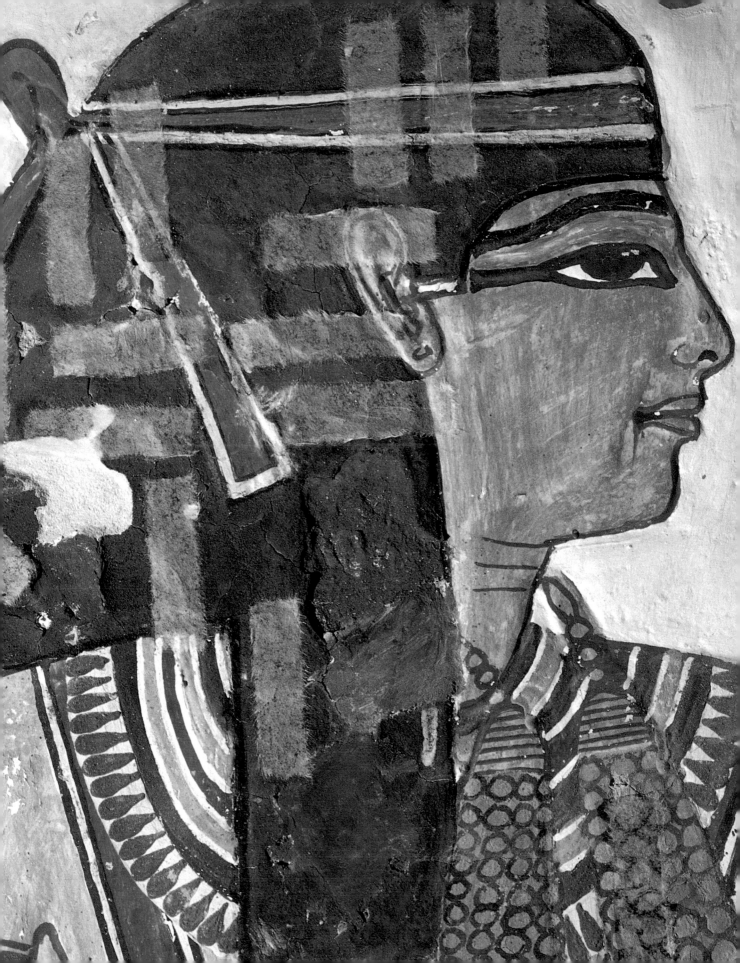

Since the tomb was opened to the public, some 150 visitors a day each spend ten minutes inside the tomb.

Photo: Shin Maekawa.

Schiaparelli's account of his opening the tomb mentions extensive debris on the chamber floors, presumably flushed in by storm water. In 1914, major flooding in the Valley of the Kings damaged the tomb of Rameses II, leaving it choked with rubble. As recently as November 1994, a modest shower in western Thebes became a torrent sweeping through the Valley of the Kings. Current estimates predict serious flooding about once every three hundred years.

In addition to all this, an ancient earthquake fractured the roof of Nefertari's tomb, opening tiny fissures that have since permitted the infiltration of surface water. In fact, apart from people inside the tomb, the principal historic mechanism for accumulation of water has been the slow seeping of moisture through these fissures and the pores of the bedrock.

Emergency conservation work undertaken in 1987 required the temporary placement of nearly ten thousand small bandages of Japanese mulberry bark paper to secure loose bits of decoration. Beginning in 1988, the actual treatment program was carried out by a team of Italian, Egyptian, and English conservators led by Professors Paolo and Laura Mora, with more than four decades' experience in the conservation of wall paintings. Guiding all their efforts was a determination to keep interventions to a minimum and to use only reversible methods and materials. The goal was to clean and stabilize, not restore, the tomb paintings; no in-painting took place.

Working under difficult conditions, the Moras and their team painstakingly consolidated flaking and chalking paint with acrylic solutions, and reattached loose and crumbling plaster by means of a special mortar made from local sand and gypsum. The final stage of work, carried out

between 1990 and 1992, involved cleaning the paintings with solvents that did not affect the pigments or gum arabic binding material.

This work took more than six years to complete. A photographic record of all phases of the work — from analysis to consolidation to cleaning — was compiled between September 1986 and April 1992. More than seven thousand images, consisting of 35 millimeter and 4 x 5 inch color transparencies, provide a complete archival record of the tomb and are the principal resource for scholars wishing to study it.

Although the tomb became a favorite tourist destination almost as soon as it was discovered, it was more often shut than open. Between the early 1970s and 1994, the tomb was closed to all but specialists and occasional VIPs. With the 1992 completion of consolidation and cleaning, pressure to reopen Nefertari's tomb grew dramatically. But three more years of scientific monitoring of the tomb environment in an undisturbed state were needed to establish base levels for future monitoring.

In November 1995, the decision was made by the authorities to open the tomb to the public. Now some 150 visitors move through the site every day, each allowed to spend ten minutes inside the tomb. Monitoring has shown that a single individual exhales and perspires between one-half and two cups of water per hour as well as carbon dioxide. So every day between five and twenty liters of water are deposited in the tomb. This moisture must go somewhere. What is not reabsorbed by people's clothing or extracted by the ventilation system is sucked up by the plaster and paint of the tomb.

Humidity within the tomb can climb to dangerous levels very rapidly. Especially during the summer, when humidity tends

to be high and natural ventilation of the tomb is less efficient, relative humidity can easily exceed seventy percent. At such elevated levels, the tomb requires from three days in winter to twelve days in summer to regain its microclimatic equilibrium.

Moreover, biological activity is triggered at only fifty percent relative humidity; and increased growth of microbes and fungi on the tomb walls may simultaneously contribute to deterioration of the paint layer. Prolonged, elevated humidity may further imperil the images by softening the gum arabic that binds the paint to the wall.

But, salt recrystallization and biological deterioration are not the only dangers. Physical damage to the fragile wall paintings, especially in the narrow entranceways, can occur easily, and the risk increases with the number of visitors in the tomb at any one time. There are other potentially adverse consequences of tourism. Apart from microorganisms, dust, and materials from visitors' clothing, there is the unknown long-term effect of artificial lighting on the wall paintings.

Continuing photographic and climatic monitoring have taken place since the completion of work in 1992. Telltale strips have been placed within the tomb to register tectonic shifts. A solar-powered monitoring station measures relative humidity, temperature, and carbon dioxide levels inside the tomb, as well as weather data externally. Spot readings by colorimeters disclose any color shifts or alterations in the paintings, and photographs provide a record of damage or change. By these means, GCI and Egyptian scientists hope to verify if the deterioration within Nefertari's tomb has been halted, slowed, or if further measures may be required.

Meanwhile, no simple equation exists for balancing the needs of tourists and the best interests of the tomb. This problem is hardly unique to Egypt. Yet Nefertari's tomb is a special case, both because of its fragility and its extraordinary beauty.

Short-term solutions have already been implemented. The Valley of the Queens has been landscaped and diversion structures installed at key points to shunt flood water away from tomb entrances. The large tour buses whose idling motors can be felt far away have been relocated still farther from the tombs, thus lessening any possible risk from vibration and pollution.

Long-term solutions include offering visitors a virtual reality tour of the tomb at a nearby museum. Similar experiments are already underway at other sites, and initial results elsewhere are encouraging. Perhaps the number of visitors to the tomb might be adjusted as humidity levels cycle, without creating too much frustration among a public eager to see one of Egypt's greatest sights.

The dangers are great. Having survived for thirty-two hundred years, the remaining original paintings now confront perhaps the greatest threat of degradation and destruction they have ever faced.

Conservators working on the west wall of Chamber C. Much of the decorated surface of this wall, which illustrates Chapter 17 of the Book of the Dead, has been lost. The entrance to the tomb can be seen on the left.

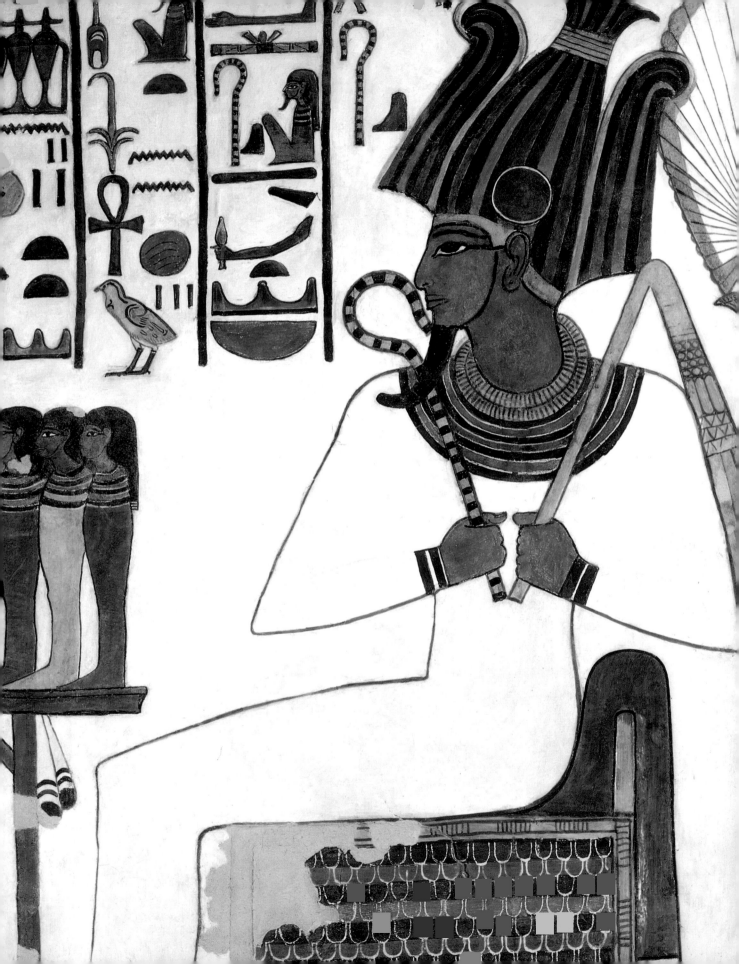

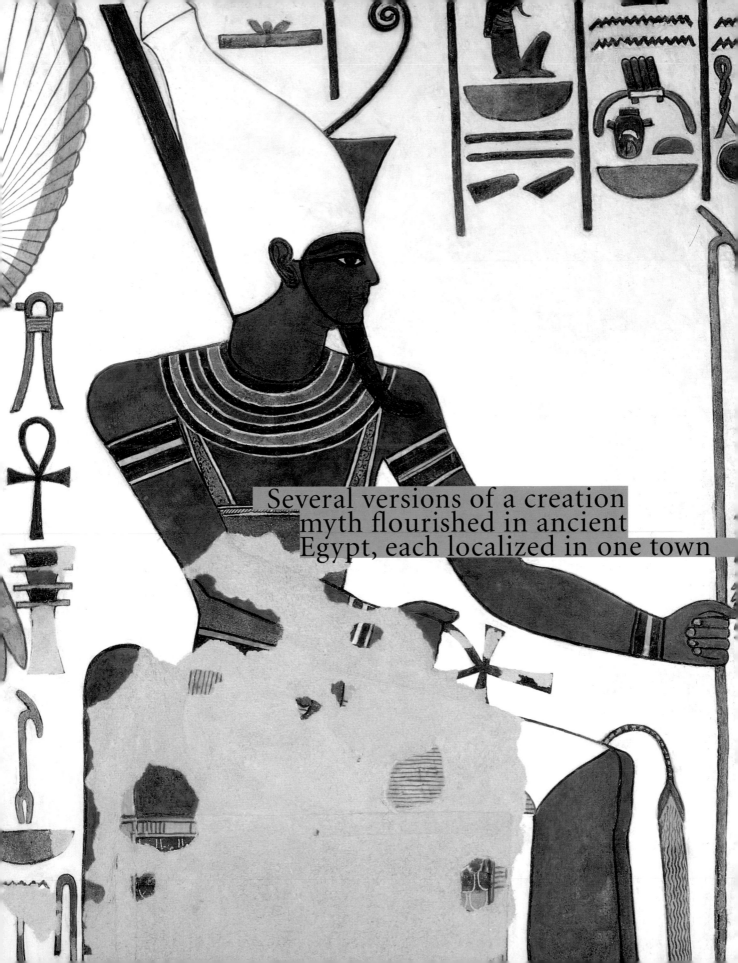

Several versions of a creation myth flourished in ancient Egypt, each localized in one town

*Previous page:
The center section of
two parallel scenes
that occupy the east
wall of Chamber G.
Osiris, on the left, is
in mummified form
and wears the twin-
plumed crown. A huge
fan separates him
from the god Atum in
human form and
wearing the double
crowns of Upper and
Lower Egypt.*

*Opposite:
Kheperi, the beetle-
headed god of the
morning sun, on the
east wall of Recess E.*

or another. The most influential and enduring of these stories related

how Atum, the creator god, emerged from the receding waters of the primeval ocean (personified by the god Nun) to squat atop a small mound. While perched upon this eminence, he engendered by masturbation both air/light and moisture. Air/light was represented as male, the god Shu; moisture as female, the goddess Tefnut. From this brother-sister pair sprang the next generation: earth, personified by the god Geb; and sky, personified by the goddess Nut. They in turn produced four divine offspring, again grouped into two pairs of sister-brother deities: Isis and Osiris, Nephthys and Seth.

These nine gods figured prominently in Nefertari's tomb. Their traditional home was Heliopolis, the City of the Sun, near modern Cairo. This Heliopolitan divine family provided a theological basis for the creation of the physical world and embodied truths about Egyptian society and attitudes toward life and death. Implicit in the scheme were such fundamental oppositions as earth and sky, female and male, order and chaos, good and evil. Even the potential for intergenerational conflict existed: Atum represented self-renewing force drawn from the sun, while Osiris represented the inevitability of physical decay.

At least as early as the Old Kingdom, the solar deity Re' was worshiped at Heliopolis. Early on, Re' and Atum were fused into Re'-Atum, a composite deity sharing attributes of both. Manifest in the late afternoon sun, Re'-Atum was the mature or setting sun.

Another version of Re', the morning or nascent sun, was Kheperi, a beetle-headed god often protrayed in royal tombs as a scarab beetle issuing at daybreak from the vulva of the goddess Nut. The intense noonday sun was the falcon-headed god, Re'-Horakhty. Temples to all these forms of Re' existed at Heliopolis; ten during the Ramesside period alone.

The chief sun symbols were the phoenix bird or heron (the *benu* bird), the sun's disk (the *aten*), and the obelisk (the *benben* stone). These appear repeatedly in the tomb of Nefertari, "for whom the sun shines."

The second and third generation of Heliopolitan gods symbolized the natural world and its basic constituents: earth, air, sky. But the fourth generation related directly to human beings and human relations. The institution of kingship was symbolized in the person of Osiris, the original earthly king. Human strife emerged in the conflict between him and his brother Seth. Their struggle was the subject of many Egyptian myths and was seen as the endless battle of good against evil, truth against falsehood.

This conflict plays out in funerary rites too. The dead needed to identify with Osiris, the ultimate model for their salvation and a protection against Seth, who represented hostile, chaotic forces that imperiled a soul's transformation into an effective, eternal spirit.

The most complete account of Osiris and the cycle of stories associated with him comes from *De Isis et Osiris*, by Plutarch, the Greek biographer and historian. This tale tells how Seth killed Osiris, either by drowning or by dismemberment, and dispersed his body parts throughout Egypt.

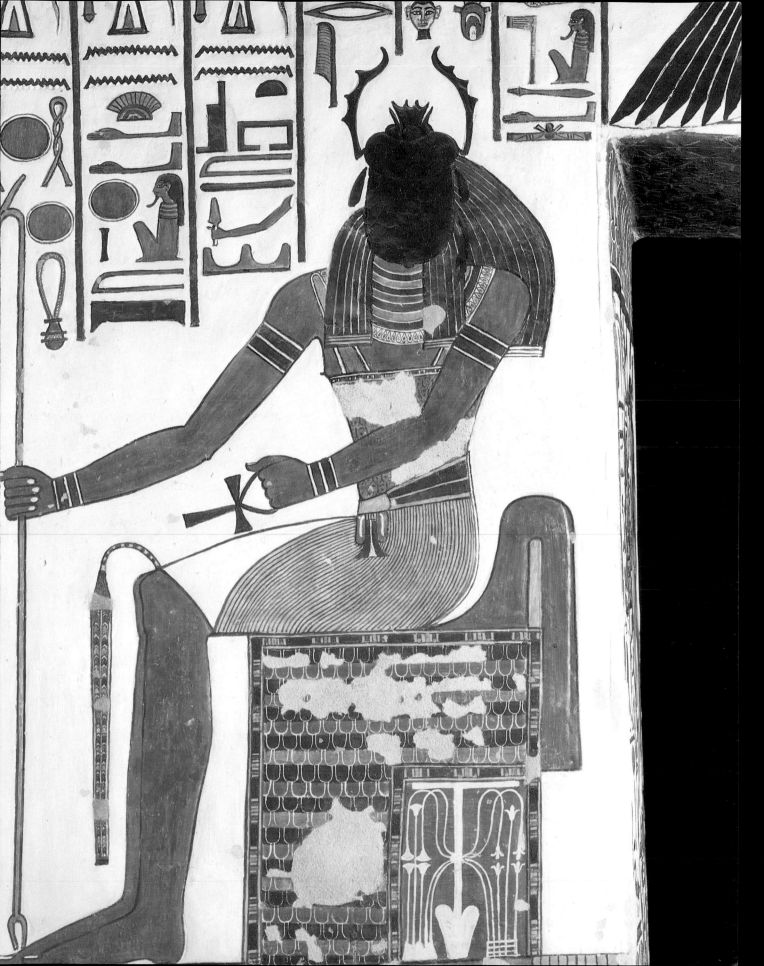

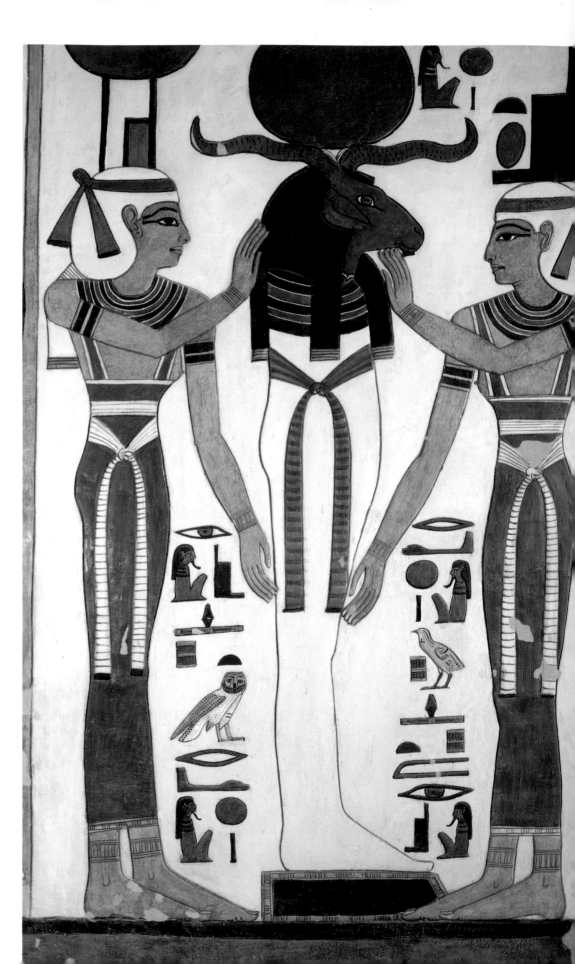

The west wall of Chamber G. The goddesses Nephthys and Isis flank a ram-headed mummified figure. The text on the left reads: "It is Osiris who sets as Re'," while the right-hand text declares: "It is Re' who sets as Osiris," thus implying the union of the two gods.

Fearing her wicked brother Seth, Isis took sanctuary in the Nile Delta marshes with her infant son Horus. During this time of exile, Horus acted as his mother's support and protector (Iunmutef: the pillar of his mother). Isis, together with her sister Nephthys, eventually reassembled her brother/husband's body, preserving it from decay. In time, Osiris was reanimated.

Most often, Osiris was depicted as a mummy, wearing either the white crown of Upper Egypt or an elaborate variation with twin plumes on either side (the *atef*). The god was swathed in linen bandages, elbows akimbo, bandage-wrapped hands crossed over his breast. He held a crook in his right hand and a flail in his left. As his hands were crossed, these regal emblems rested on opposite shoulders.

Osiris' face, the only exposed part of his body, was often green, an explicit evocation of vegetal life and its annual renewal. New Kingdom private tombs often had "Osiris beds" — gauze frames in the outline of Osiris — with seeds strewn on them to sprout in the darkness of the tomb, a convincing demonstration of renewal and rebirth.

All Egyptians hoped to become an "Osirianized" being. But that depended on passing the judgment of Osiris, a scene illustrated countless times in tombs and funerary papyri, chiefly from the New Kingdom.

The deceased is ushered into the judgment hall, usually by Ma'at, the goddess of cosmic order and truth. Osiris sits in royal majesty accompanied by Isis, his

The djed *pillar became a symbol of the backbone of Osiris. This one, in Chamber M, is equipped with two human arms holding* was *scepters and with* ankh *signs around the wrists.*

consort. In the center of the room looms an enormous balance beam. In one pan is the heart of the deceased; in the other, Ma'at's Feather of Truth. Thoth, the ibis-headed god of writing, stands ready to record the result of this trial. Close by, a fierce demon, "the great swallower," is poised to devour the hearts of those who fail the test.

Throughout her tomb, Nefertari is consistently referred to as "the Osiris," so confirming her successful completion of this crucial step in her quest for immortality.

Divine Guidance

Clad in a leopard skin garment, Horus appears on the south face of Pillar 1 in the form of Horendotes officiating as a priest.

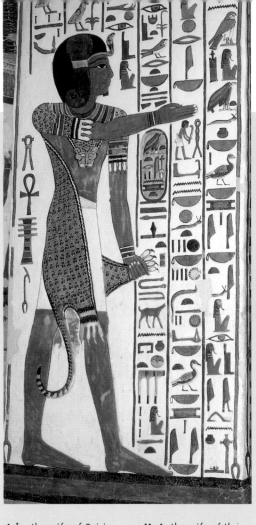

Akeru a lion-headed earth god associated with the eastern horizon and the morning sun

Amun the preeminent god of Egypt from the Middle Kingdom onward, whose home was Karnak Temple in Thebes

Aten the ancient Egyptian designation for the sun disk, which, personified, was worshiped as the great deity of creation by the pharaoh Akhenaten

Atum originally a sun god worshiped at Heliopolis; regarded as a protective deity associated with the rituals of kingship

Edjo the tutelary goddess of Lower Egypt, her cult center was located in the Delta city of Buto. She was represented as a cobra

Hathor a goddess of many functions and attributes who was often shown either with a cow head or as a woman with cow's ears and horns. Known as the "Golden One," she was said to suckle pharaohs and was later identified by the Greeks with Aphrodite

Horus a falcon deity originally worshiped as a sky god. Later identified with the reigning pharaoh and regarded as the son of Isis and Osiris

Isis the wife of Osiris and mother of Horus. The chief protector-goddess, assimilating to herself many of the attributes of Hathor and eventually becoming an extremely popular Egyptian deity during the Roman imperial period

Ma'at called the daughter of Re'. A goddess personifying truth, justice, and the divine order of the universe and present at the judgment of the dead. Usually portrayed wearing a feather atop her head

Mut the wife of the state god Amun. Her principal cult center was the southernmost of the three precincts at Karnak. She was represented either as a vulture or as a woman

Neith a creator goddess of antiquity; symbolized with a shield and arrows. Often shown wearing the red crown of Lower Egypt

Nekhbet a goddess who sometimes appears as a vulture, had her cult center at Elkab, south of Luxor,

The goddess Ma'at on the east wall of the descending corridor.

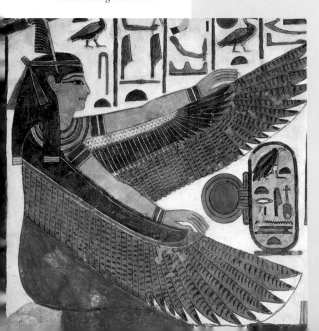

where she was, from very early times, worshiped as the tutelary deity of Upper Egypt

Nephthys the sister of Isis, who came to represent mourning in general because of her lamentations at the death of the god Osiris

Nut the sky goddess who was thought to swallow the setting sun Re' every evening, and give birth to him each morning

Osiris the husband of Isis, dismembered by Seth, his evil brother. Osiris was reassembled by his wife Isis and posthumously conceived his son and successor, Horus. For these reasons, he was considered to be the god of the underworld and offered the hope of resurrection

Ptah the creator god of Memphis, a site located to the southwest of modern Cairo. Represented as a mummy and later equated by the Greeks with their god Hephaestus

Re' like Atum, a manifestation of the sun god of Heliopolis. Often linked to other deities, such as Amun, in cults aspiring to universality

Re'-Horakhty a god in the form of a falcon whose name, Horus of the Two Horizons, represents the union of Re' and Horus as a universal solar deity

Thoth the Egyptian god of wisdom and writing, often depicted as an ibis-headed male figure to whom scribes traditionally addressed a prayer before beginning their work

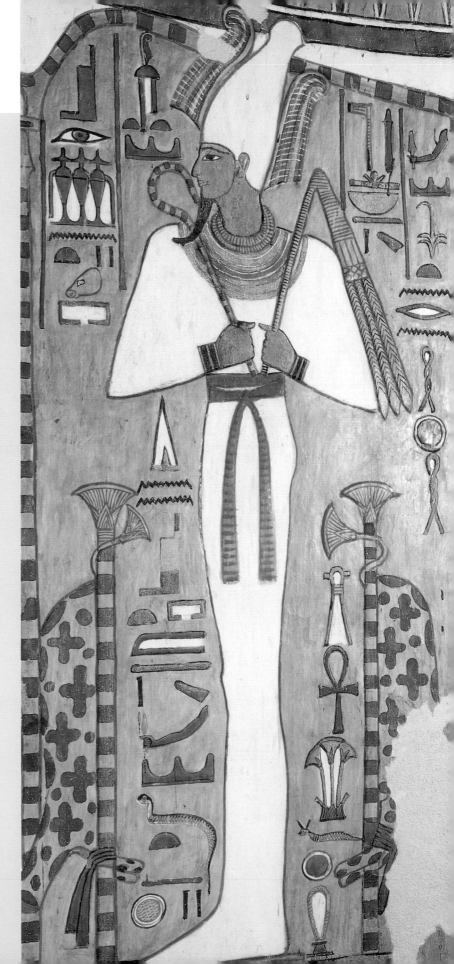

Osiris, in mummified form, on the east face of Pillar III in the sarcophagus chamber.

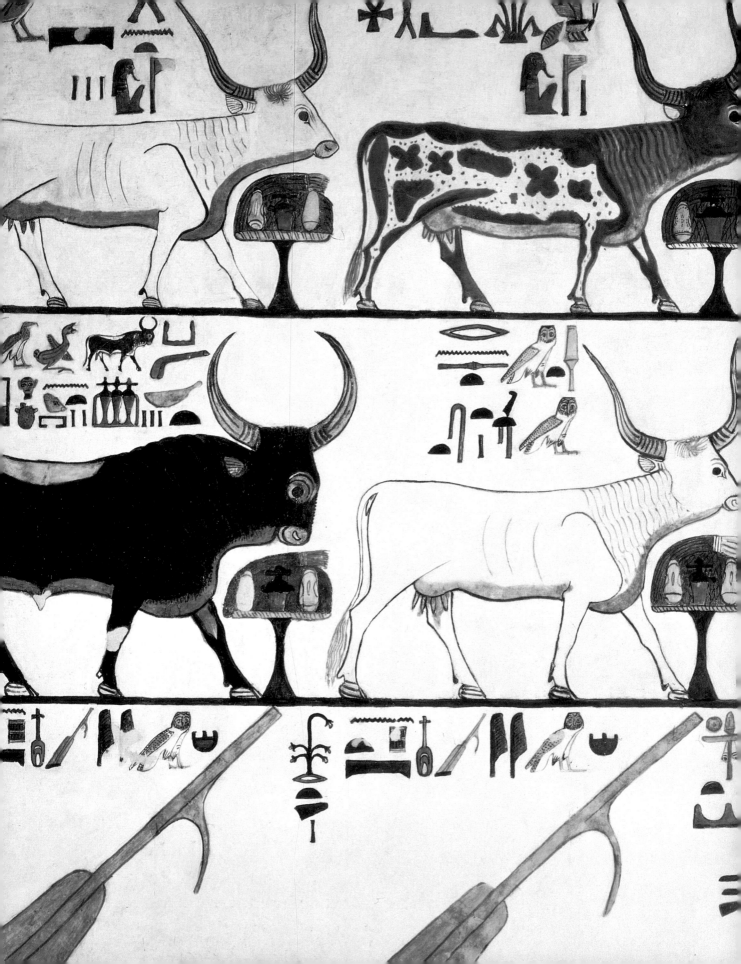

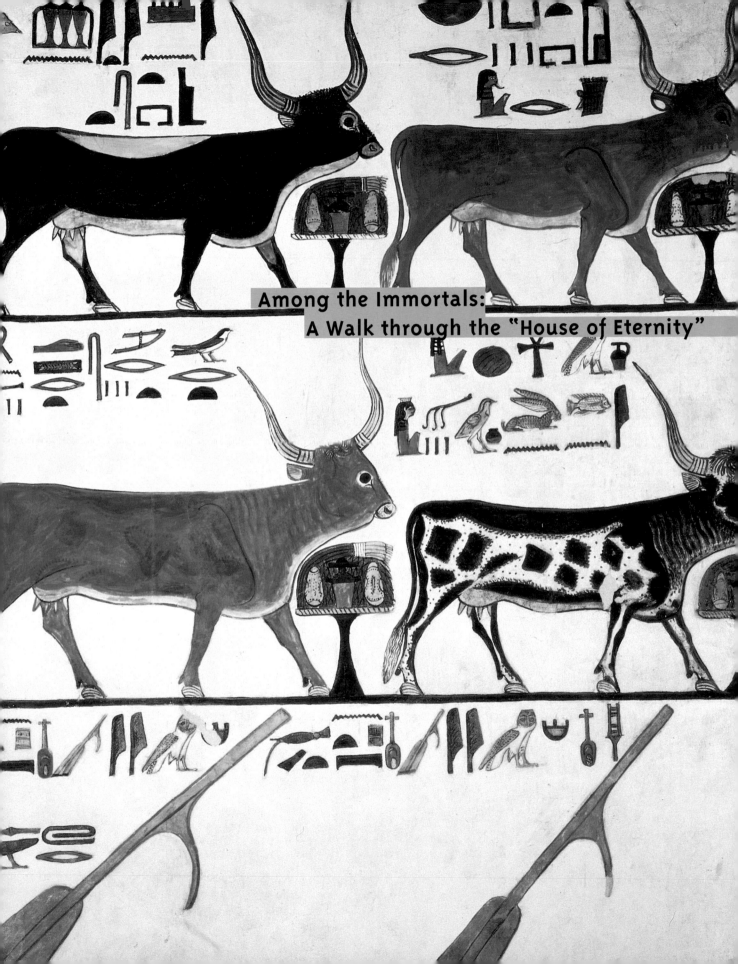

Among the Immortals:
A Walk through the "House of Eternity"

Like the river Nile, the geographic course of the tomb runs south to north. Its ritual course, however, is east-west, corresponding to the course of the sun. The initial descent angles slightly to the northwest, leading to an entrance chamber with recesses and an auxiliary chamber to the east. From this entrance hall, a second descent, oriented due north, leads yet lower to the second level and the burial chamber itself.

From the wall paintings we can see the story of Nefertari's journey to the hereafter unfold. In the upper chambers, her body is preserved and she is greeted by divinities who grant her a place in the netherworld. Thus fortified with occult powers, she begins her descent to the burial chamber. Here she secures immortality by enduring an ordeal of passage through the gates and portals of the netherworld. Having met all the challenges, Nefertari's body is restored by Horus, son of Isis, in his guise as officiating priest. The queen then takes her place in the netherworld, eternally united with Osiris.

Two essential aspects define Nefertari's "house of eternity": aesthetics and meaning. These two aspects exist simultaneously within the tomb, as illustrated vignettes and hieroglyphic texts. Though visually captivating, neither illustrations nor texts are immediately intelligible to most viewers. In this walk through, the vignettes are described and interpreted. Some of the shorter hieroglyphic texts are translated in the body of the section, while longer texts appear as sidebars. Italicized words are defined within the text or in the margin the first time they appear.

Previous spread: The illustration of Chapter 148 from the Book of the Dead occupies the entire south wall of Chamber G. In front of each of the seven cows and the bull are offerings of vegetables, milk, and bread.

The entrance to the tomb at the time of its discovery by Schiaparelli in 1904.
Photo: Courtesy of the Museo Egizio, Turin.

Descent and Entrance

A flight of eighteen steps with central slipway leads down from the gate to the tomb entrance. This first stairway is undecorated, but the door jambs and lintel identify the tomb as Nefertari's.

The text on the left jamb is nearly obliterated; but the one on the right may still be read: "Hereditary noblewoman; great of favors; possessor of charm, sweetness, and love; mistress of Upper and Lower Egypt; the Osiris; the king's great wife, mistress of the two lands, Nefertari, beloved of Mut, revered before Osiris." The lintel bears faint traces of the setting sun flanked by two *oudjat* eyes and *cartouches* of the queen surmounted with the double plume.

To the left, the door *thickness* is badly damaged. But the figure of Nekhbet, the vulture goddess of Upper Egypt, can be made out, together with her name. Her utterance—that she has given life to Nefertari—has all but vanished. On the right *reveal* are equally fragmentary traces of Edjo, the cobra goddess of Lower Egypt. The pairing of these two deities expresses the division of Egypt into northern and southern kingdoms, united by King Menes in the distant past. Although largely symbolic, there may have been some historical foundation to this separation.

The trapezoids formed between the sloping roof and the upper margin of the scenes are filled with coiled and winged serpents who confer life and dominion on the queen. The door *soffit* carries a representation of the sun setting behind a sand hill and flanked by two kites, birds whose shrill cries recall mourning women.

The left bird wears the emblem of Isis, the right that of Nephthys. The setting sun signals that we have entered the nighttime realm of the dead, who are accompanied by Isis and Nephthys, sisters of Osiris, king of the netherworld.

THE TEXTS IN THE TOMB

Since Nefertari was not a sovereign, the choice of texts that could appear in her tomb was restricted. The architects and priests who determined the decorative program chose selections from chapters of the Book of the Dead.

Texts in the Book of the Dead evolved from utterances that first appeared in the Sixth Dynasty pyramids of the Old Kingdom and were further elaborated in coffin texts during the Middle Kingdom.

Called by the Egyptians "The Book of the Coming Forth by Day," the Book of the Dead consisted of nearly two hundred utterances intended to help guide the dead on their journeys into the beyond. These texts, or "spells," expressed the aspirations of ordinary Egyptians to flourish in the netherworld and join the community of imperishable spirits. Not all the texts in the book had to be actually inscribed to be effective.

Well-known chapters of the Book of the Dead included the canopic formula for protection of the viscera (Chapter 151); the heart scarab text to restrain the heart from bearing witness against the deceased (Chapter 30); a formula for the servant figurines, called *ushabtis*, who toiled in place of the dead, performing specific, laborious tasks in the hereafter (Chapter 6); and the negative confession, in which the dead professed to have done no harm to widows, children, or their fellow men (Chapter 125).

Inscribed in the tomb of Nefertari are portions of Chapters 17, 94, 144, 146, and 148.

oudjat literally, the healthy eye

cartouche on Egyptian monuments, an oval or oblong figure containing the name of a ruler or deity

thickness the side of an opening in a wall, such as a door or window

reveal the jamb of a door or window; the thickness of the door frame

soffit the horizontal, lower edge of a roof or the underside of a molding that projects along the top of a wall; the inside surface of a vault or an arch

senet from the ancient Egyptian verb meaning to pass [someone or something],the word is applied to a board game consisting of thirty squares with movable gaming pieces anciently termed the dancers. In certain funerary contexts, the deceased is represented playing this game alone. His/her unseen opponent symbolizes Fate, who must be defeated in order to gain immortality in the hereafter

ba in Egyptian mythology, the soul, symbolized by a bird with a human head; that part of the soul free to leave the tomb temporarily

sekhem powerful, to have power

Chamber C

Within the tomb itself, the first chamber is nearly square (5 x 5.2 meters), with a rock-cut table along its west and north sides. Scenes on the right-hand side of this room relate to the recesses and chamber beyond. On the left, however, the inscription and vignettes are drawn exclusively from Chapter 17 of the Book of the Dead.[1]

This chapter asserts the identity of the gods Re' and Atum, a theological equation dating at least to the Old Kingdom. On a deeper level, its theme is the transformation of the queen into an effective being in the afterlife, one who will join the company of Osiris. Her ability to do so depends less on any special knowledge that she may possess than on the text itself, structured as a series of questions and responses. Chapter 17 is one of the longest and oldest spells in the Book of the Dead.[2]

In the illustrations on the south wall, the queen is shown in three of her different transformations: first, playing *senet*; next, as a *ba*; and finally, adoring a composite,

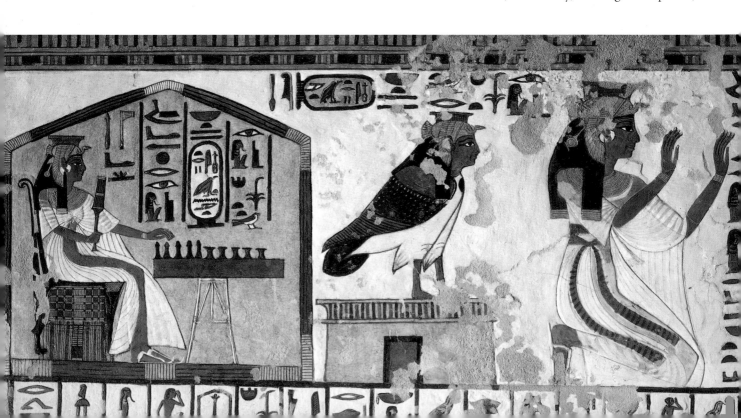

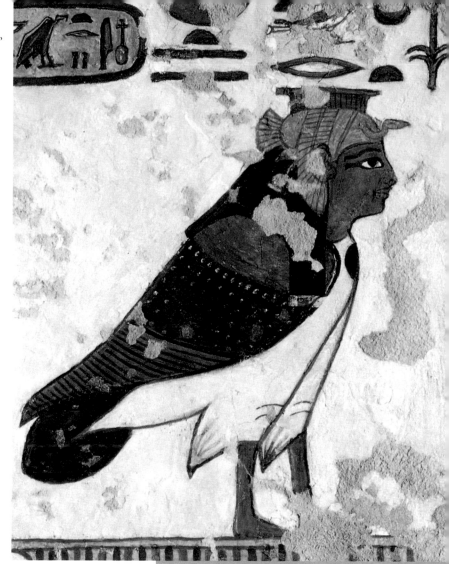

lion-headed god. The first two transformations are explicitly mentioned in the opening of Chapter 17. On the left, Nefertari sits on a high-backed chair resting on a reed mat, the gaming table before her. The entire scene is framed within a shelter made of reeds. The queen is dressed in a sheer white gown reaching to her sandals and wears a vulture-headed cap or headdress. In her right hand is a *sekhem* scepter, and with her left she is just about to move a *senet* piece. The rest of the space is filled with her name and titles.

The next vignette shows the queen as a *ba* bird perched atop a low shrine. The *ba*, the mobile portion of Nefertari's soul, is free to leave the tomb temporarily. The figure of the kneeling queen, her hands raised in adoration, seems curiously placed until we realize that it is meant to address the twin-headed lion god, the earth god, Akeru, on the west wall.

Akeru is actually a complex of images: the sun rising above the horizon and the sky above are integral to this image. It is meant to invoke the morning sun, a recurrent metaphor for rebirth in Egyptian art. All three figures on the south wall are paying homage to this composite figure, Akeru.

The *senet* scene, the *ba*, and kneeling figure were frequently shown together in contemporary funerary papyri. Here, however, the architecture of the tomb required that this scene be folded at the corner.

Opposite:
The illustration on the south wall of Chamber C shows Nefertari in three transformations: playing the board game senet; *as the human-headed* ba *bird; kneeling in adoration.*

Detail from Chamber C, south wall. The ba *bird, representing the soul, was free to travel outside the tomb during the day.*

BOOK OF THE DEAD

1 In funerary papyri, text and illustration are integrated in one long, continuous roll, but here the artists separated image and text, placing illustrations in the upper register and words in the middle. The correspondence between the two is therefore interrupted and, in a few instances, not close at all.

2 The introductory chapter heading is contained in the first nine columns and succinctly summarizes its overall intent. It reads: *"Beginning of the praises and recitations to come forth and go down into the Necropolis, to be spiritualized in the Beautiful West,* *the coming forth by day in order to assume the forms among any forms he [sic] wishes, playing* senet *and sitting in the booth, coming forth as a living* ba *by the Osiris, the king's great wife, mistress of the two lands, Nefertari, beloved of Mut, justified after he [sic] died. It is effective to do this on earth, so that it happens entirely according to instructions."*

The use of masculine pronouns in reference to the queen suggests the copyist lost his concentration from time to time, a natural enough response, given that the funerary honors accorded Nefertari were highly unusual for a woman.

A god, his hands stretched over two ovals containing oudjat *eyes, on the lintel over the entrance to Recess D.*

On the west wall are a half dozen vignettes. Next to the image of the earth god, there is an especially effective image of a heron or *benu*, a bird with phoenix-like qualities, often labeled as the soul of Re'.

The central image of this register, a kiosk sheltering a mummy on a lion-headed bier, sounds a distinctly funerary note. The white mummy shell is bound with red linen bands, and a funeral mask covers the mummy's head. A canopy of bead work is stretched over it but appears as a backdrop. The kites have taken up their customary positions as sentinels: Nephthys at the head, and Isis at the foot.

The kneeling god to the right is a water god, shown dark-skinned, with pendulous breasts. His left hand is poised on an oval containing a stylized falcon eye. This grouping is a *rebus* for *shen* and *oudjat*, two hieroglyphic tokens for protection and health. With his right hand, the water god holds a notched palm rib, symbolizing abundance of years, presumably his gift to Nefertari.

The following two vignettes and text are seriously degraded. Only traces survive of a standing figure, facing right. In the funerary papyri, he is called "the great green," possibly a reference to fecundity.

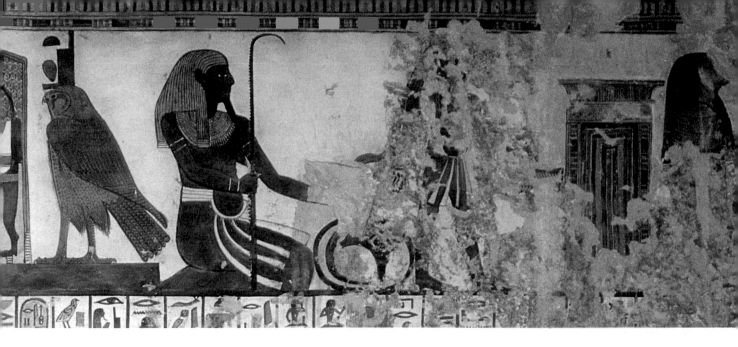

The final cluster of images on this wall shows a flat-roofed shrine with *cavetto* cornice and a scene involving a seated, falcon-headed god. Beyond is a faint suggestion of another *oudjat* eye. Textual references to these images appear on the north wall of the room.

From left to right, the text of Chapter 17 continues to scroll its way along the north wall, ending at the left door jamb that marks the descent to the burial chamber. The vignettes in the upper register do not correspond to the texts beneath.

Much-ravaged at the left hand is the image of a reclining cow, the Celestial Cow. She is followed by a symmetrical grouping of the sons of Horus, in pairs on either side of a wooden shrine. Within the shrine is an image of Anubis, depicted as a recumbent jackal.

Facing this cluster are two seated mummiform figures, one falcon-headed, the other human. The first is likely Re', the second, Shu, the divine form of light and air. All these illustrations coordinate with portions of Chapter 17, but their position in the funerary papyri can vary greatly.

The stone table that runs along the north and west sections of Chamber C has a semicircular molding and cavetto cornice with alternating bands painted red-blue-green-blue against a white background. The table was probably designed to hold funerary equipment destined for the celebration of the cult of the dead queen. Along the table's front, niches have been hollowed out, three on the west and two on the north, leaving what seem to be stout piers to hold it up. These all carry the queen's title: "king's great wife Nefertari, beloved of Mut."

The backs of the niches are painted to resemble three round-topped, wooden shrines, not unlike a little coffer found in the tomb clearance and now in Turin. Possibly its place was under this table, in one of the niches. On the left inner face of the northern niche, west side, is a docket recording a delivery of plaster to the "right" and "left" gangs of workmen who excavated this tomb. The text around the edge of the table is Osiris' declaration of his intent to provide Nefertari a place in his realm and in the divine assembly, as well as to give her the appearance of her father, Re'.

In the middle of the north wall, the decoration breaks. The orientation of the figures makes this clear. On the east side, we see five figures facing right. The four farthest to the east are the sons of Horus, genii whose role is to guard the viscera of

The upper section of the west wall of Chamber C before conservation illustrating sections of Chapter 17 of the Book of the Dead. Careful examination of these vignettes—especially the heron and the funeral bier—afford an ideal chance to observe the balance maintained between carving and painting.

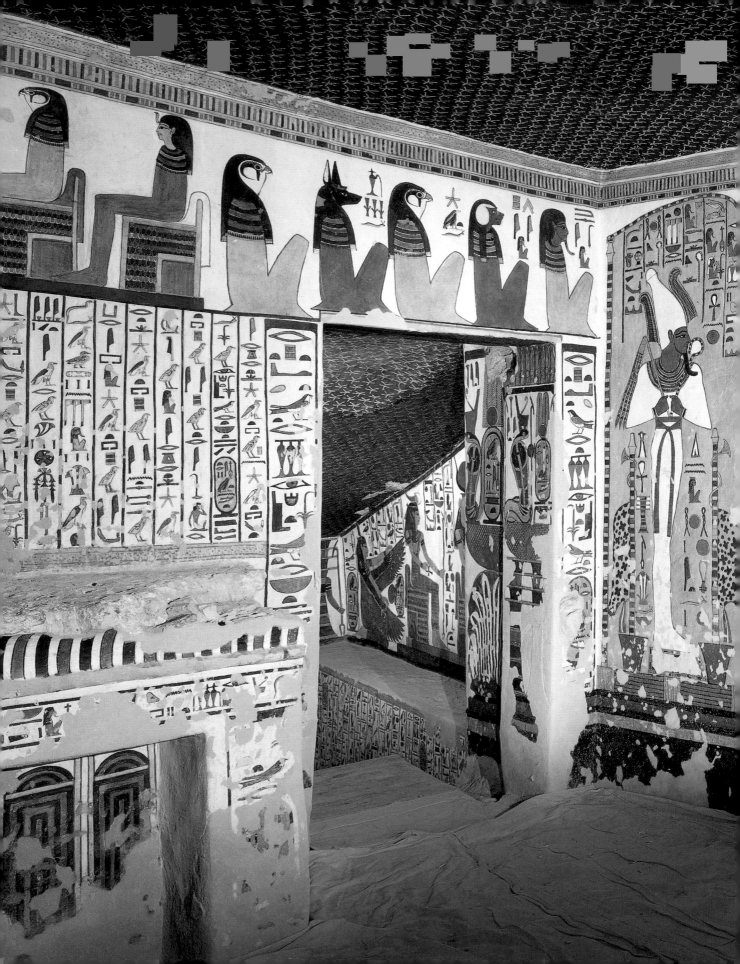

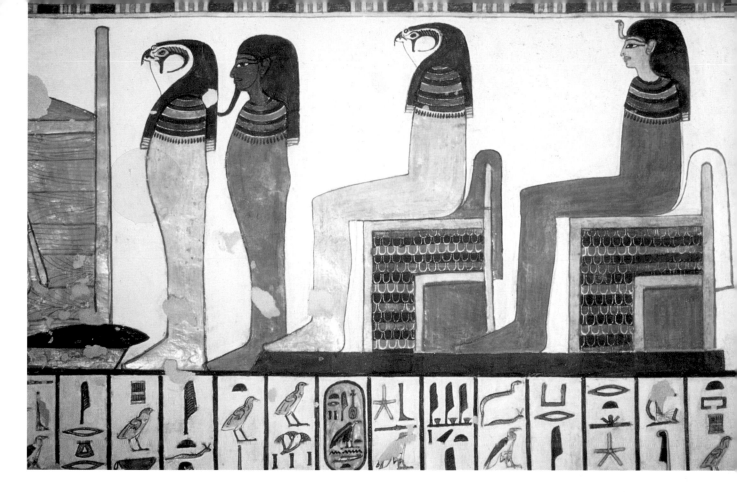

the deceased. From the right, they are Imsety, a human-headed guardian responsible for the liver; the baboon-faced Hapy, custodian of the lungs; Qebehsenef, the falcon-headed keeper of the intestines; and a canine, Duamutef, who has charge of the stomach. The scribe mistakenly exchanged the names of Qebehsenef and Duamutef. Behind them sits an anonymous falcon-headed god, perhaps Horus himself.

The prominent placement of these figures above the door leading to the lower reaches of the tomb and the sarcophagus is thoroughly appropriate, as the queen's viscera were stored below, in the tiny niche

Opposite:
The north wall of Chamber C including the entrance to the descending corridor. The five figures over the entryway are the four sons of Horus

whose roles are to guard the deceased's viscera. The falcon-headed figure to their left, though unspecified, is thought to be Horus himself.

cut in the west side of the burial chamber. Each of these minor gods is assigned one of the cardinal points of the compass, and each associates with one of four goddesses — Isis, Nephthys, Serket, and Neith — deities who appear on the *canopic* vessels and the exterior of many coffins.

Returning to the entrance to Chamber C, on the eastern part of the south wall (right of the entrance), we find a scene of Nefertari as a supplicant before a seated figure of the mummiform Osiris. The queen faces into the tomb and Osiris out, thus establishing the fundamental orientation of figures. The gods are, in a sense, already resident in the tomb, and so they face out, like hosts greeting a most esteemed guest, in this case, the queen herself.

Nefertari has her hands raised in homage to Osiris. She is robed in a white pleated garment with a red sash about her waist. It is a luxurious garment, altogether typical of the elaborate fashions of the Ramesside court. It is also the dress of

Detail from north wall of Chamber C showing figures illustrating Chapter 17 of the Book of the Dead.

canopic chest in ancient Egypt, a chest with four urns containing the mummified internal organs of the dead. Named after Canopus, a seaport in the Nile Delta east of Alexandria, where they were first recognized

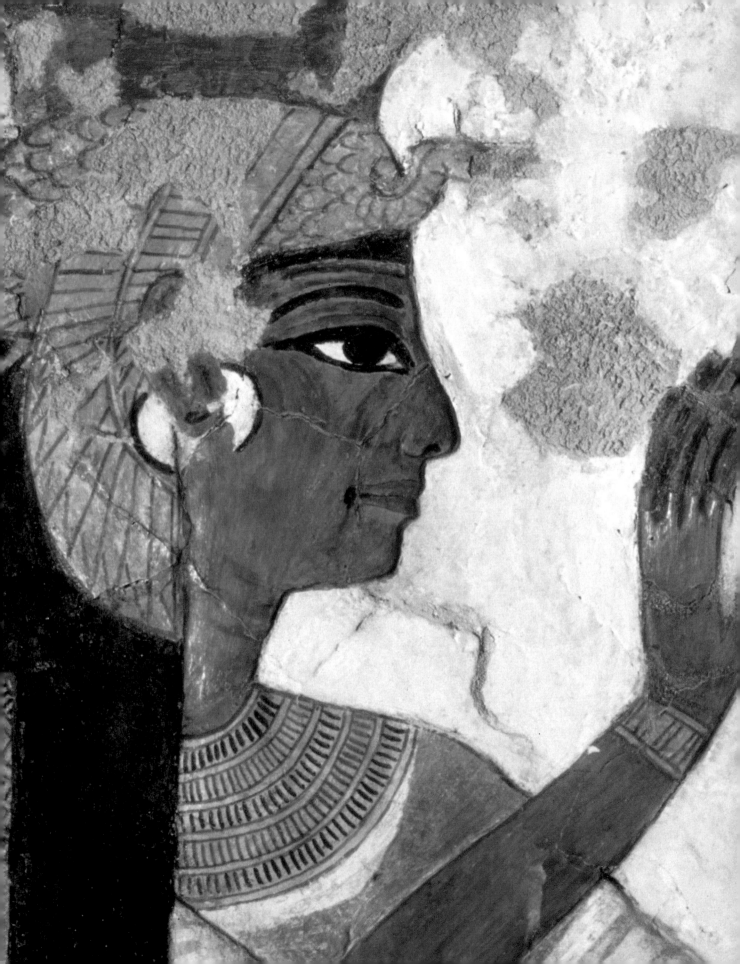

a human being, one who comes from the perishable world. The queen wears her characteristic headdress: a twin-plumed vulture cap. She is identified as "the Osiris, king's great wife, and mistress of the two lands, Nefertari, beloved of Mut, justified before the great god."

The great god is, of course, Osiris, who is seated in a kiosk to the left. The kiosk is topped by a frieze of rampant serpents *(uraei)* with sun disks, resting on a striped cavetto cornice. Osiris wears an elaborate crown called the *atef*. Made of papyrus, it imitates the bulbous white crown of Upper Egypt, but has ostrich plumes affixed to each side. He is swathed in mummy bandages and clasps the crook, a token of kingship, and the flail. His hands are crossed over his chest. The flesh of the god is green, signifying his formidable powers of rejuvenation. Between him and the queen is a narrow table with mummiform figures of the four sons of Horus. Behind Osiris are amuletic devices signifying protection *(sa)*, life *(ankh)*, stability *(djed)*, and dominion *(was)*.

uraeus via the ancient Greek word for tail, this term is generally applied to the cobra, which the ancient Egyptians associated with Edjo, the tutelary goddess of Lower Egypt, and which, together with Nekhbet, often decorated the brow of the pharaoh. By extension, the cobra might be employed as a motif connoting protection in a general sense

atef similar to the white crown of Upper Egypt but with ostrich plumes affixed to each side

sa protection

ankh life; an ancient Egyptian symbol of life, consisting of a cross with a loop at the top

djed stability. The *djed* amulet was a hieroglyph representing a bundle of stalks tied together, reproduced in various media as a symbol connoting stability, endurance, and the like

was dominion

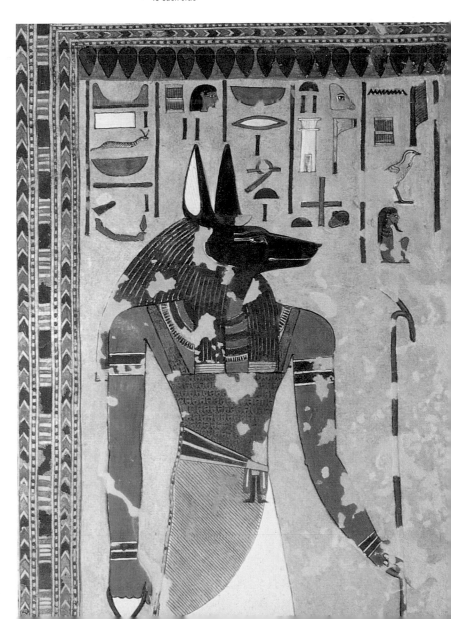

Opposite: Detail from the south wall, east side, of Chamber C. Nefertari is standing in adoration before an enthroned Osiris.

The jackal-headed god, Anubis, on the south side of the east wall of Chamber C.

Preparation for Recesses and Side Chamber G

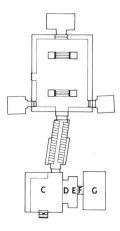

From the middle of Chamber C we can look east through Recesses D, E, and F to side Chamber G. The sides of the frame of the first recess are composed of a standing figure of Osiris on the left and, on the right, the figure of Anubis, Osiris' son by Nephthys. Both figures look toward Nefertari, as if to coax her forward.

The lintel, the upper framing device, links the two compositions. On it is a frieze of rampant *uraei*, alternating with blue feathers, facing outward from a central figure of a god whose hands are posed over two ovals containing *oudjat* eyes. This frieze is reminiscent of the *shen* and *oudjat rebus*. The feathers symbolize Ma'at while the cobra has generic protective properties.

The standing image of Osiris shows him within a shrine with high-arched roof. The god now wears a less-detailed version of the *atef* crown: feathers astride the white crown of Upper Egypt. The customary regalia are in his hands. The curious device either side of Osiris is a leopard skin twisted about a rod set in a mortar. It is the fetish of Anubis and is profoundly linked with this god's role as the principal embalmer of the dead. In fact, Anubis appears on the right panel of the frame, a jackal-headed god clutching a *was* scepter in his left hand and *ankh* sign in his right.

The scenes in the recesses and beyond do not form a unity. The architecture has constrained the artists, requiring them to mix scenes that have no clear connection. The gods shown are those featured in the Heliopolitan cycle of deities.

In decorating these recesses, the artists have cleverly paired divine images on left and right surfaces, thus defining the processional axis. The climax will occur in Chamber G, with the back-to-back juxtaposition of Atum, the creator god, and Osiris, quintessential god of salvation and Atum's great-grandson.

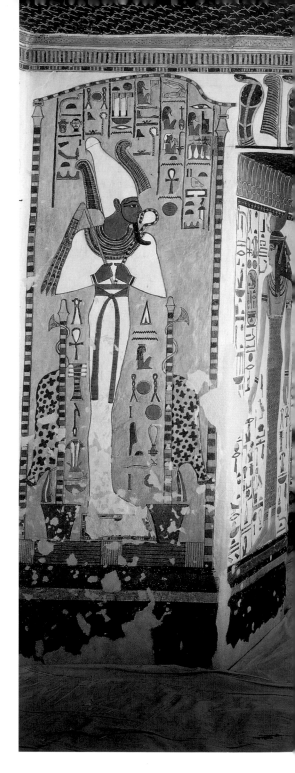

Osiris and Anubis flank the entranceway to the recesses and Chamber G.

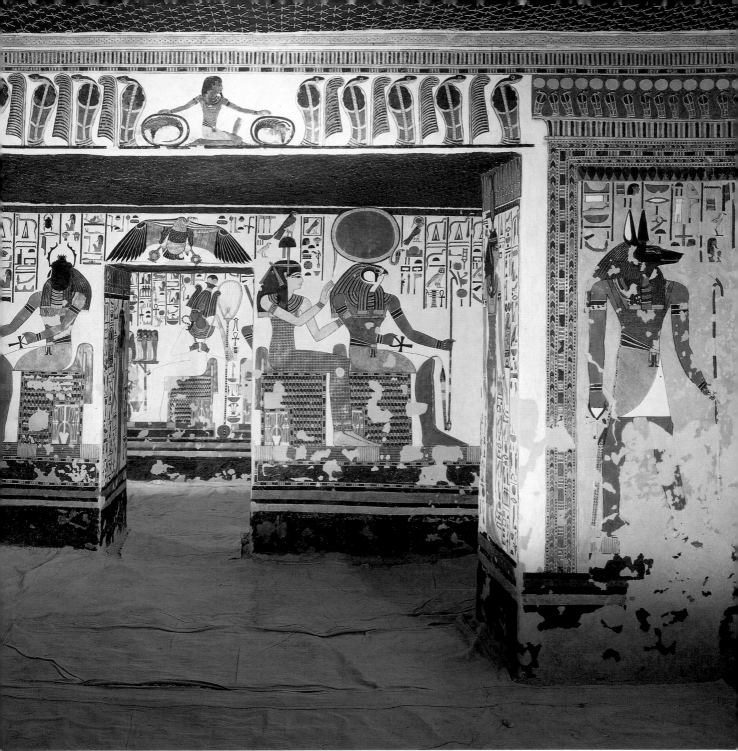

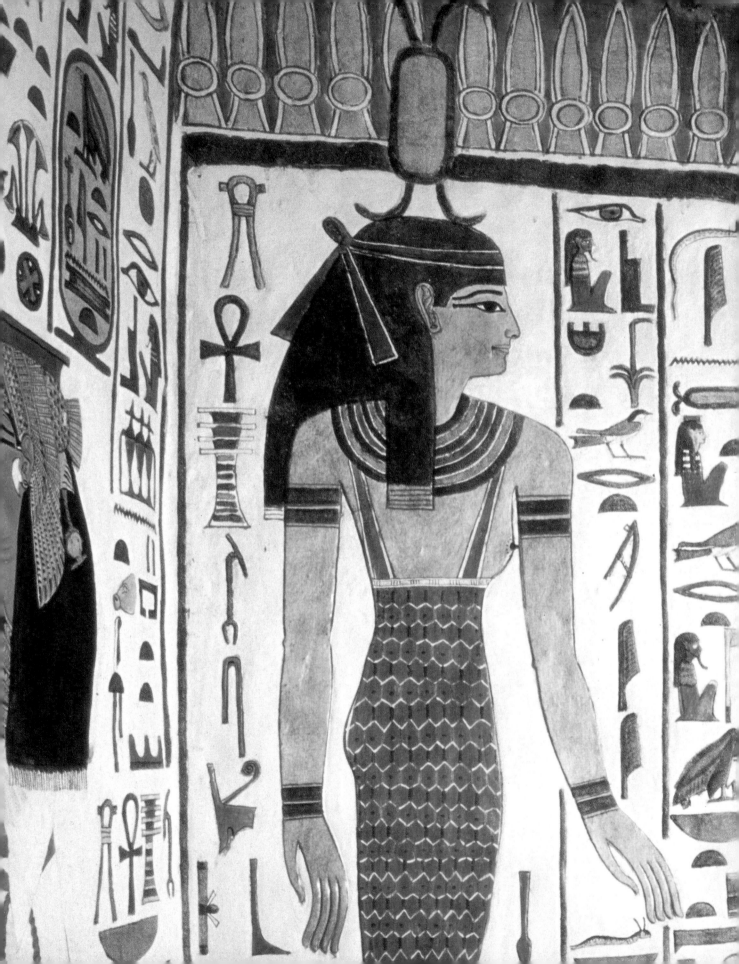

Detail of hieroglyphs from the south wall of Recess D.

Opposite:
The depiction of Neith on the east side of the south wall at the top of the descending corridor is very similar to that on the south wall of Recess D. In both instances the artist has intentionally drawn Neith's emblem so that it bursts through the picture frame, even obscuring a portion of the kheker *frieze. This is a small but remarkable breach of the artistic convention.*

Recess D

Now we pass through Recess D, two opposing pilasters that define the entryway to Recess E. On the left (north), is the goddess Serket (or Selkis), identifiable by the scorpion on top of her head. She is framed above by a *kheker* frieze, a common architectural ornament representing knotted bunches of vegetal matter such as reeds or grass. Beneath is a representation of the nighttime sky or starry firmament. Serket wears a richly beaded dress with thin shoulder straps, a broad beaded collar, armlets, and wristlets. She faces outward in welcome. Behind are a series of protective emblems that form a benediction of sorts: "protection, life, stability, dominion, all protection like Re', forever."[3]

A complementary welcoming scene occurs on the right-hand (south) pilaster. This time, the goddess is Neith, whose signature emblem rests atop her head: a greatly stylized image of two bows tied together or possibly a shield and two crossed arrows. She too is dressed in a tight-fitting sheath of beadwork. Protective emblems stand at the ready behind her.[4]

BOOK OF THE DEAD

[3] The text reads: *"Serket, mistress of heaven and lady of all the gods. I have come before you, [oh] king's great wife, mistress of the two lands, lady of Upper and Lower Egypt, Nefertari, beloved of Mut, justified before Osiris who resides in Abydos, and I have accorded you a place in the sacred land, so that you may appear gloriously in heaven like Re'."*

As with all the gods who now guide Nefertari and welcome her to the netherworld, Serket's statement *"I have come before you"* indicates that the goddess is ready to aid the queen in the new realm that now awaits her, the hereafter. Thus the queen can rest assured that she is in good hands.

[4] Her utterance reads: *"Words spoken by Neith, the great royal mother, mistress of heaven and lady of all the gods. I have come before you, king's great wife, mistress of the two lands, lady of Upper and Lower Egypt, Nefertari, beloved of Mut, justified before Osiris who resides in the West, and I have accorded you a place within Igeret, so that you may appear gloriously in heaven like Re'."*

Recess E

In Recess E, the pilasters both right and left (behind you as you enter) are decorated with images of the *djed* pillar, a talisman of the god Osiris. The connection with Osiris is manifestly evident in this instance; indeed, the image *is* Osiris, as a *djed* pillar. The exact components are difficult to identify but seem to consist either of stacked vertebrae or bound vegetal elements. Its hieroglyphic meaning is "stability"; and as the distinction between writing and art in ancient Egypt was very vague, its use on a supporting element in the tomb is witty. This clever playing off of decor against architectural function is used to even greater effect in the burial chamber below.

As we enter fully into the recess separating Chambers C and G, we come upon two presentation scenes. On the left, the queen is inducted by Isis into the presence of Kheperi, the seated god with the head of a beetle. On the right side of the recess, Horus Son-of-Isis (Horsiese) leads the queen before seated images of Re'-Horakhty and the Theban Hathor.

Starting with the left-hand scene on the north wall, Isis wears bovine horns, a solar disk between them, and a *uraeus* draped over the solar disk. Her hair is bound with a *fillet*. About her neck is a broad collar whose weight is supported by a *menat*, or counterpoise, visible under her right arm. Isis wears the tight, red, beadwork dress with which we are now familiar. Arm bands and wristlets complete her ensemble of jewelry. In her left hand she holds a *was* scepter; and with her right, she takes Nefertari's hand, gently drawing her forward.

Urging her on, Isis says: "Come, [oh] king's great wife, Nefertari, beloved of Mut.

fillet a thin strip of cloth or other substance circling the head and used to hold the hair in place

imbricated ornamented with an evenly spaced, overlapping pattern, in the manner of fish scales

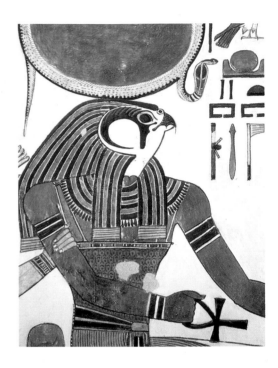

I have made a place for you in the necropolis." Nefertari, again clothed in the whitest, pleated linen, strides forward. Note that she is shown with two left feet. Her name and titles appear above her in three columns, interrupted by the twin, high-plumed crown we now expect.

The scene wraps at the wall juncture. As we look straight forward (east), we see whom Isis and Nefertari confront: an anthropomorphic deity with the head of a beetle. He is seated on an *imbricated* throne base with the unification symbol in the lower right quadrant. This is a heraldic device made of the plants of Upper and Lower Egypt, twisted about a stylized representation of the lungs and windpipe, the hieroglyph for unity.

The falcon-headed god, Re'-Horakhty, crowned with a sun disk, on the east wall, south side, of Recess E.

Opposite: Nefertari being led by the goddess Isis on the north wall of Recess E.

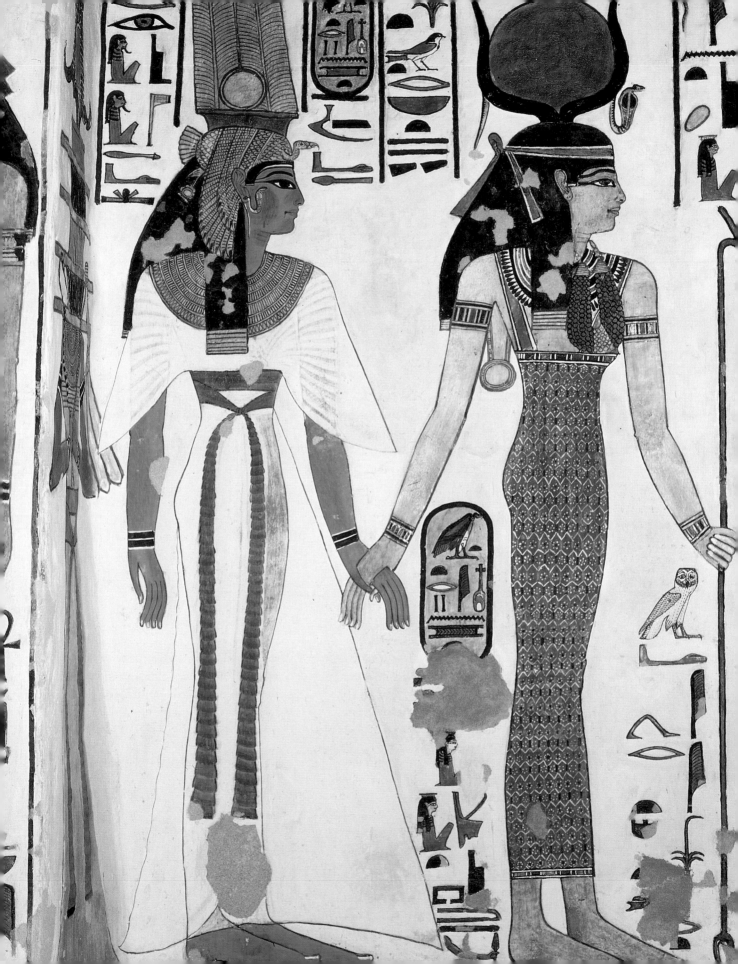

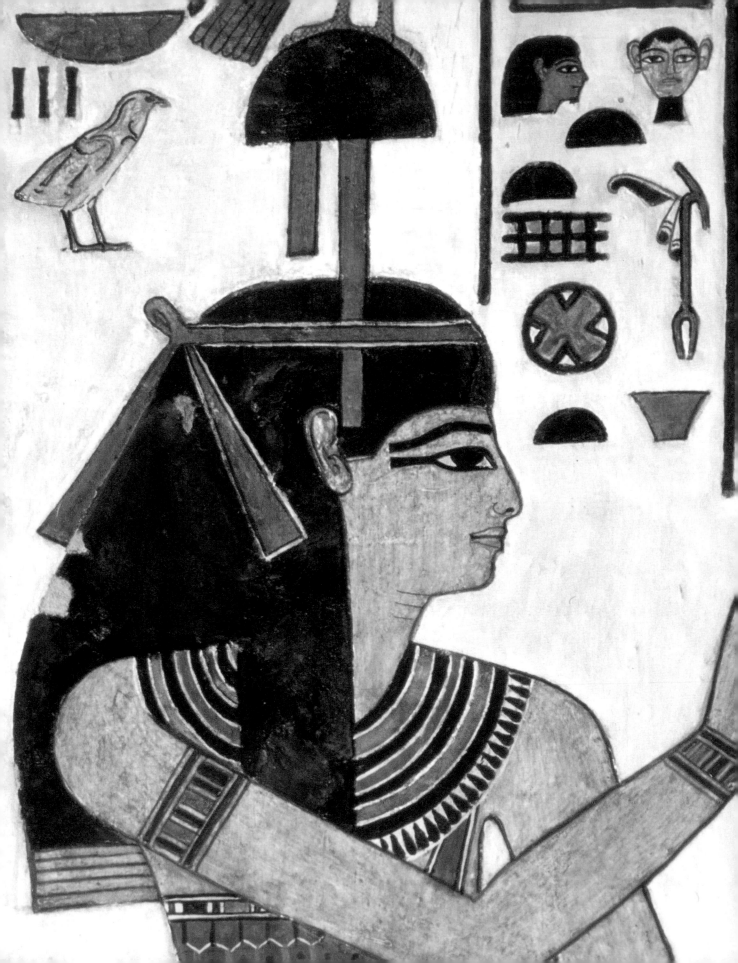

The god is dressed in a heavy wig, broad collar, green vest held up with shoulder straps, and short kilt *(shendyet)* with a bull's tail, traditional ceremonial dress for gods and kings. He holds the *ankh* sign in his left hand and a *was* staff in his right. Words above the god promise Nefertari "everlastingness like Re', the appearance of Re' in heaven, and a place in the necropolis."

This is Kheperi, the nascent sun god, the morning light. The word "Kheper" is related to the verb meaning "to change or transform"; *kheperu* are forms that a god or human can assume. Thus, Kheperi represents the possibility of Nefertari's transformation through death to a new existence.

The right-hand presentation scene is analogous to the left, except that Horus Son-of-Isis (Horsiese) conducts the queen. He appears as a god with a falcon head, wearing the double crown of united Egypt. Called the *pshent,* this crown combined the red and white crowns that signify Lower and Upper Egypt. Its name means "the double powers." He too wears the *shendyet,* but with the bull's tail trailing behind. Although the label in front of Horsiese mentions his utterance, none is recorded.

The south side of the east wall of Recess E. The goddess Hathor has her arm raised to touch the headdress of Re'-Horakhty seated in front of her.

The pair approach two gods seated on low imbricated thrones: the falcon-headed god is Re'-Horakhty; behind him, Hathor, who resides in Thebes. Re'-Horakhty is dressed almost identically to Kheperi, except for his characteristic solar disk and looping *uraeus.* He utters three short texts. These promise a place in the sacred land, a lifetime as long as that of Re', and eternity, with life, stability, and dominion. Re'-Horakhty, whose name means Horus-of-the-Twin-Horizons, represents the mature sun at midday. Both throne bases display the unification symbol.

The lintel that links these two scenes is emblazoned with a vulture holding in each talon a *shen* sign. The legend appearing between the roof and forward edge of the wings proclaims this to be the vulture Nekhbet, patroness of El-Kab and Hieraconpolis, twin cities of Upper Egypt. Her function is to protect those who pass beneath.

Notice that this doorway is off axis, shifted slightly left. It is possible this was done to accommodate scenes of different dimensions, but more likely the decoration was adapted to suit the tomb's architecture. Despite the axis shift, the primary scene in the chamber ahead—back-to-back figures of Atum and Osiris—is exactly on the axis of the door.

The lintel over the doorway from Recess E shows the vulture Nekhbet with wings outstretched and a protective symbol in each claw.

Recess F

This entrance to side Chamber G is an ideal opportunity to observe the star-spangled roof of the tomb: five-pointed yellow stars against a blue background. Multiple associations signal not only night-time but also the imperishable circumpolar stars, astral sentinels who never sink below the horizon and were thus equated with the souls of gods and beings who survived the perilous passage through death to the beyond.

Each side of the doorway is decorated with an identical panel: beneath a *kheker* frieze and sky sign is the figure of Ma'at, the goddess of truth and daughter of Re', gazing out toward Nefertari. Ma'at is dressed not in a bead-net dress but a cling-ing red shift. Her distinguishing feature is the feather on her head.

The protective talismans behind Ma'at are more varied than those we have encountered previously. From top to bottom, they offer "protection, life, stabil-ity, dominion, all health, all joy, and all her protection, like (the protection of) Re'." Locating Ma'at so prominently is probably significant. In most funerary papyri, one of the crucial rites of passage is the judgment of Osiris, in which the heart of the deceased is weighed against Ma'at's Feather of Truth. Neither the judgment scene, nor Chapter 125 of the Book of the Dead, appears anywhere in Nefertari's tomb. Instead, it is echoed in these portraits of Ma'at.

The color of the ceil-ing is achieved by painting blue over a layer of black. The superimposed yellow stars were laid out along parallel guidelines snapped onto the ceiling from taut cords dipped in white paint.

The goddess Ma'at, with the identifying feather in her head-band, on the north side of Recess F. The decoration on the opposite side of the doorway is identical.

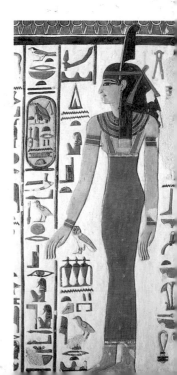

Chamber G

Chamber G is about 3 meters deep and 5 meters wide. The ratio of width to depth is 1.66, remarkably close to the ratio of the depression in the queen's burial chamber (1.65) and the northern annex (1.66). This fraction, not far off the "golden" proportion of 1.61, recurs in Egyptian architecture. This chamber also provides the best view of the rock floor of the tomb.

On the left-hand (west) interior wall, behind us, is a single scene framed by the customary sky hieroglyph resting atop two *was* scepters. Nefertari presents cloth to Ptah, one of the principal creator gods. The queen holds her hands up, palms flat, to support a tray bearing four forked supports, the hieroglyph for cloth. On the table in front of her is yet more fabric, labeled linen.

Nefertari offers this to Ptah, the god of ancient Memphis, Egypt's first capital. Swathed in his *cerements,* Ptah stands in a wickerwork booth with arched roof; he peers out at the queen through a small grill, open in front of him. Ptah clutches a staff made of the *was* and *djed* emblems bound together. Above is an assortment of amulets offering "protection, life, stability, dominion, all health, all joy, all his protection, like Re'." This scene bears no apparent relation to any other in the room and is not an illustration from the Book of the Dead. It is likely an example of the concept called in Latin *do ut des:* "I give in order that you might give."

The entire north wall of Chamber G is covered by a single presentation scene to the ibis-headed Thoth, god of writing. Thoth sits on an imbricated throne set on a low plinth; he regards the queen across a stand that holds a writer's palette, a water bowl, and a frog amulet. This frog may be what is called a sportive writing for *whm-'nh,* "repeating life," a wish for longevity.

Standing in the very middle of the wall, the queen occupies center stage. Bracketed by text behind and Thoth in front, Nefertari is identified as "king's great wife, mistress of the two lands, Nefertari, beloved of Mut, justified before the great god (Osiris)."

In eight columns of text behind the queen is the entirety of Chapter 94 of the Book of the Dead. The columns appear in standard order, facing right and reading from right to left.[5]

Thoth is the patron of writing and functions in judgment scenes as the recorder. With Thoth, Ma'at at the entryway, and Osiris on the back wall, the principal players in the standard judgment scene have all been assembled. As the queen is repeatedly referred to as "the Osiris," it is certain that she has successfully completed this essential rite of passage, even though it is not shown.

cerements burial garments; a shroud made of cloth treated with wax and used to wrap the body of the deceased

Detail of the god Ptah on the west wall, north side, of Chamber G. In this vignette, Nefertari is giving linen to Ptah to ensure a reciprocal and ample supply for her corpse. This is typical of the contractual arrangements between devout Egyptians and their gods.

[5] The first two columns provide the chapter heading and subject: *"Utterance for requesting the water bowl and writing palette from Thoth in the Necropolis by the king's great wife, mistress of the two lands, Nefertari, beloved of Mut, justified."*

The queen's recitation is next: *"Oh great one who sees his father, keeper of the writings of Thoth. Behold, I am come spiritualized, with a soul, mighty, and equipped with the writings of Thoth. Bring me the messenger of Akeru (the lion-headed earth god) who is with Seth. Bring me the bowl, bring me the palette from that of Thoth, their secrets within them. [Oh] Gods. Behold, I am a scribe. Bring me the excrement of Osiris [for] my writings, that I may perform the instructions of Osiris, the great god, perfectly every day, consisting of the good which you have decreed me. [Oh] Re'-Horakhty, I shall act the truth and shall attain the truth."*

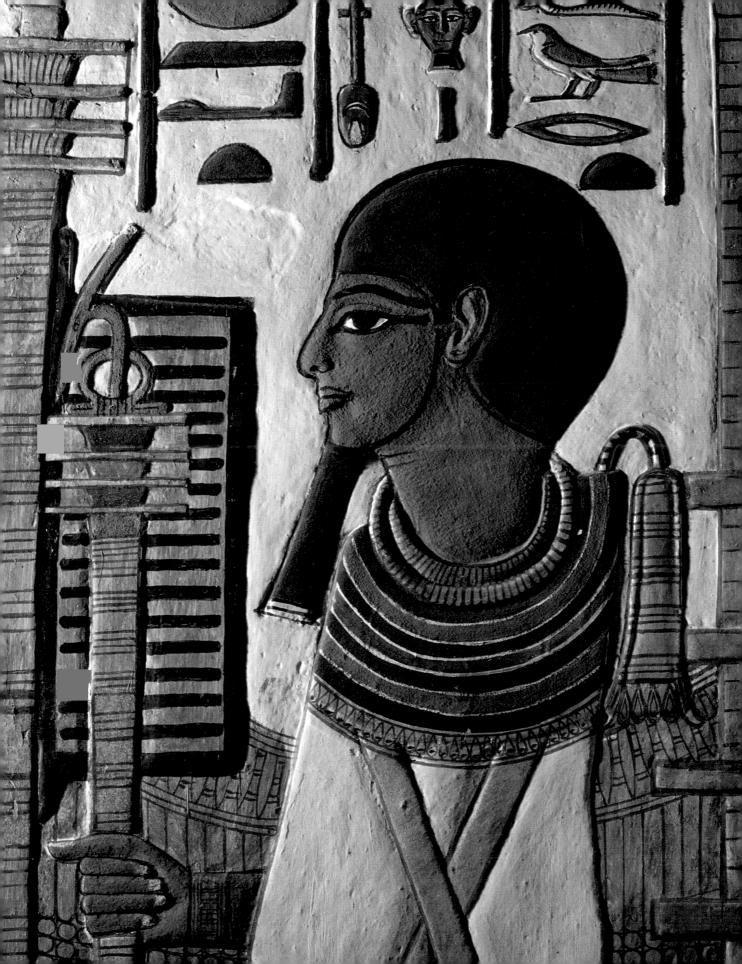

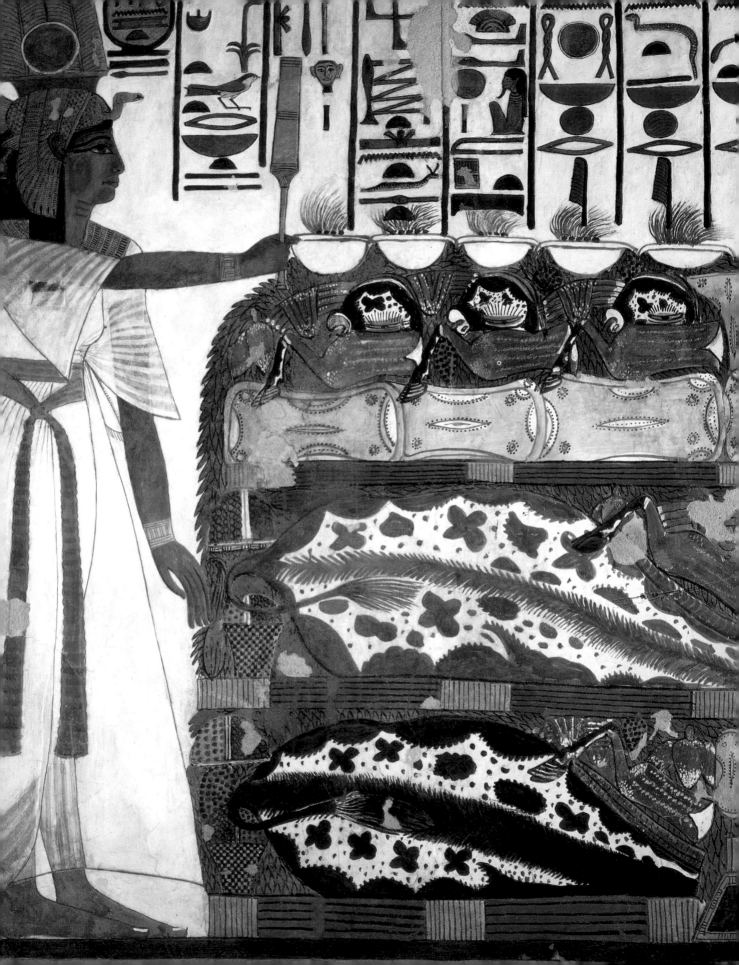

On the long east wall of Chamber G is the climactic scene of the complex of rooms formed by the recesses and side chamber, the very reason for their existence. The religious philosophy it embodies is also significant. Two presentation scenes are juxtaposed back-to-back: on the left, Nefertari before Osiris; on the right, the queen before Atum. Functioning as a scene divider, a huge flabellum, or fan, mounted in an oval stand, separates Osiris and Atum.

In both scenes, the queen is attired in a white pleated gown. On her head is the familiar crown. In both, her left hand is by her side. In her extended right hand, she holds a *sekhem* staff, signifying her power to make offerings. Some asymmetries of posture result; but from a ritual point of view, this was the best solution. The right hand should hold the staff.

Lighted, smoking braziers rest atop bountiful offerings prepared for the gods. The left altar supports a towering pile of food stuffs heaped onto three mats. Recognizable are cuts of meat, loaves of bread, and vegetables. Receiving these is Osiris, shrouded in his white cerements and seated upon an imbricated throne with unification symbol, a reed mat, beneath. He holds his customary regalia and wears the *atef* crown, this time made of rushwork. Small images of the four sons of Horus rest on a stand before him, and just beneath may be seen the fetish of Anubis.[6]

Opposite:
In this part of the long scene occupying the entire east wall of Chamber G, Nefertari is standing before a pile of offerings of meat, bread, and vegetables.

The companion scene shows the queen presenting her burnt offering to Atum. The god is portrayed in the double crown of Upper and Lower Egypt. He wears a false beard held in place by a chin strap. In his hands are an *ankh* sign and a *was* staff. Protective devices are arranged vertically behind him. We learn that he is "Atum, lord of the two lands, the Heliopolitan, the great god and lord of the sacred land."

As it captures the first instance that Nefertari makes a formal presentation to Osiris, paramount lord of the dead, this scene in Chamber G marks a crucial moment in the queen's spiritual journey. Although the sepulchral overtones of the encounter are minimized, funerary associations are always present where Osiris is concerned. Thus Atum, the creator god, is here communing with his great-grandson, Osiris, the savior god, who survived death and dismemberment. Osiris' triumphant metamorphosis to eternal life was a feat that all deceased hoped to duplicate.

BOOK OF THE DEAD

6 A four-column inscription above the queen describes *"the presentation of offerings* [iabet] *to her father, Osiris, the great god, by his daughter, king's great wife, mistress of the two lands, Nefertari, beloved of Mut, justified."*

Nine columns of text over the altar and facing away from Osiris summarize his intention of giving Nefertari *"the appearance of Re' in heaven, all infinity with him, all eternity with him, and all joy with him. Osiris, who resides in the West, Wen-nefer, king of the living, the great god, ruler of the sacred land, lord of eternity, ruler of infinity."*

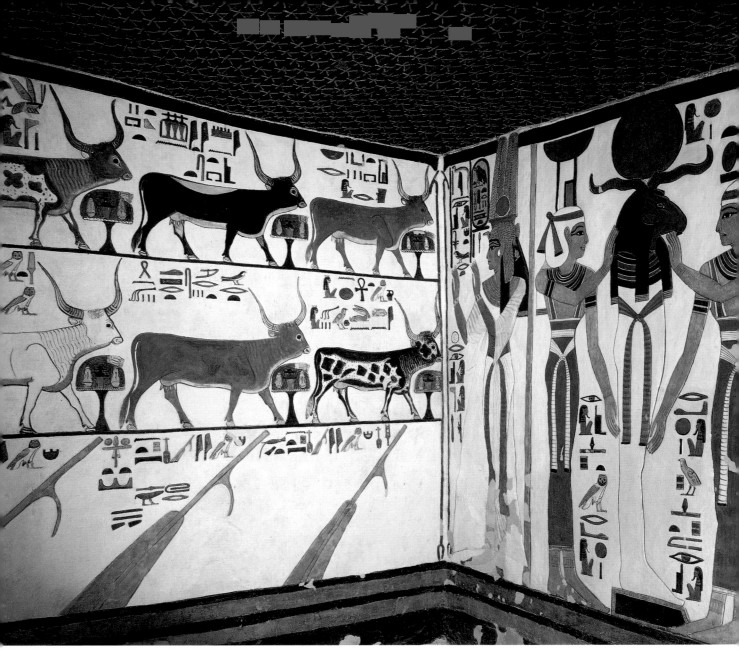

The south and part of the west walls of Chamber G. The seven cows and the bull are addressing Nefertari on the adjacent wall.

The next scene occupies the entire south wall and, for lack of space, continues onto the southern portion of the west wall. It is an evocation of Chapter 148 of the Book of the Dead. Beneath a sky sign and framed by *was* scepters at either end are four cows in the upper register, three cows and one bull in the middle. In front of each is a small altar with offerings of vegetables, milk, and bread.

The animals are meant to address Nefertari, who has been placed on the adjoining wall for lack of space. Each cow is distinguished by its hide and a particular legend above. The text of Chapter 148 reveals that these seven cows have the power to provide the spirit of the dead queen with the necessities we see displayed: milk, bread, and vegetables.

In the same spell, there are references to steering oars that help the deceased maneuver among the stars. With Re' serving as the queen's helmsman and the oars guiding her pilgrimage, none of Nefertari's enemies will know or even recognize her — so the text promises. Each oar is named and linked with a compass direction.

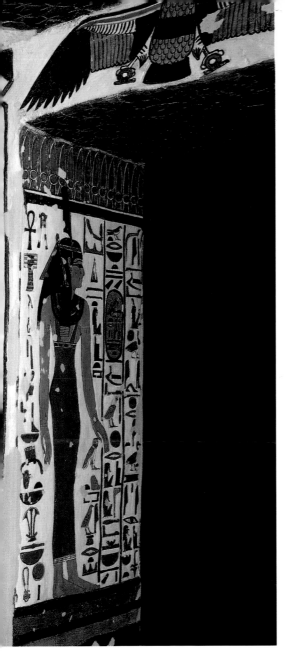

previous scene from the one immediately south of the doorway. This is a curious but theologically important grouping of a ram-headed mummiform figure standing on a small plinth.

Between the ram's horns is a solar disk. The figure wears a broad collar and red sash. Ministering to him are Nephthys, to the left, and Isis, to the right. Each wears a bag wig *(afnet)* with long queue, kept in place by a red *fillet,* and a tight, red sheath dress. The dresses are held in place with shoulder straps that expose the goddesses' breasts. The scene takes place beneath the sky sign and is framed by the vertical band to the left and a *was* scepter along the door jamb.

The ram-headed god is identified as Re'. Between the goddesses and his mummiform figure are two bands of text. The left avers: "It is Osiris who sets as Re'." The right: "It is Re' who sets as Osiris."

Egyptian theologians are here declaring that Re' and Osiris are profoundly intertwined. Yet this is not an obvious alliance, since Osiris represents the *chthonian,* earth-bound cults that seem to stand in opposition to solar imagery. The polarity can be expressed in countless ways: night versus day, earth versus sun, and so forth. Such fusing of the qualities and traits of Egyptian gods — a practice known as "syncretism" — occurs often. Re' represents the expiring sun ready to begin once more the nighttime journey into the realm of the dead, Osiris' kingdom, so thrusting the two gods into partnership.

The scene is well preserved and a superb example of balanced draftsmanship and excellent execution. Over the door is the tutelary image of Nekhbet with *shen* signs in her talons.

The cow and oar images exist for the benefit of Nefertari who has been relegated to the adjacent wall, where she stands with arms raised in adoration. Her lotus-bud earring is particularly splendid, and the modeling of the flesh of her neck with three painted strokes is remarkable. No words are actually ascribed to the queen; but presumably she utters the invocation that is an integral part of Chapter 148, a request that the cows provide her sustenance.

Like an enormous punctuation mark, a broad, raised band of relief severs the

82

Doorway to the Descending Corridor

The descent leading from Chamber C is off axis, shifted appreciably right. In the absence of any obvious structural reason for this, perhaps the architects were trying to introduce an unexpected twist, in imitation of the "crookedness of the beyond." This impression is further heightened by a skewing to the right of the descent passage itself.

The door jamb marking the entryway to the descent proclaims the queen's formal name in outsized hieroglyphs. The passageway has two widths: a narrow, outer thickness and a wide, inner one.[7]

The right outer thickness shows a rampant serpent facing the queen's cartouche, which is surmounted by double plumes and a solar disk and rests on the hieroglyph for gold. The serpent wears the red crown of Lower Egypt and is identified as Edjo, the cobra goddess. A *kheker* frieze and sky sign define the upper boundary of the composition and a fancy woven basket the lower. Twin *djed* pillars support the entire scene beneath. Considerable paint and plaster have been lost along the right-hand edge.

The corresponding left-hand scene is almost identical. Omitted is the serpent's name; but since it wears the double crown of united Egypt, we assume it is Nekhbet.

The inner thickness at the head of the stairs is exceptionally interesting. Opposed serpents representing Nekhbet and Edjo shield the queen's cartouche. The whole design is balanced on a woven basket. Underneath, on the left, is a tub of lilies, heraldic plant of Upper Egypt; on the right, a tub of papyrus, heraldic plant of Lower Egypt. This pairing symbolically establishes the mythic orientation of the tomb: south (Upper Egypt) is to our left, and north (Lower Egypt) to our right. Straight ahead, therefore, is the "west," the domain of the dead.

Looking down the descending corridor to the burial chamber from Chamber C, 1904.

Photo: Courtesy of the Museo Egizio, Turin.

7 Here, Nefertari is called *"the hereditary noblewoman, great of favor, the Osiris, king's great wife, mistress of the two lands, Nefertari, beloved of Mut, justified."*

BOOK OF THE DEAD

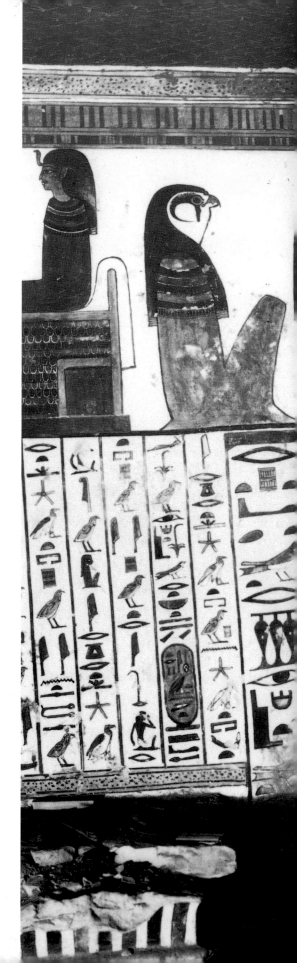

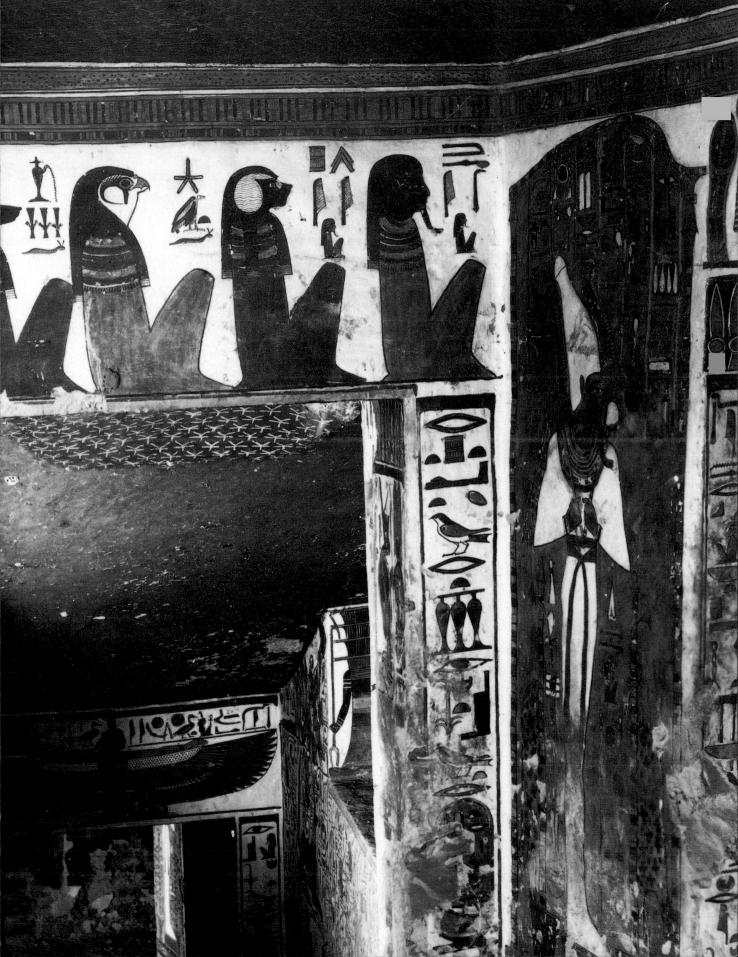

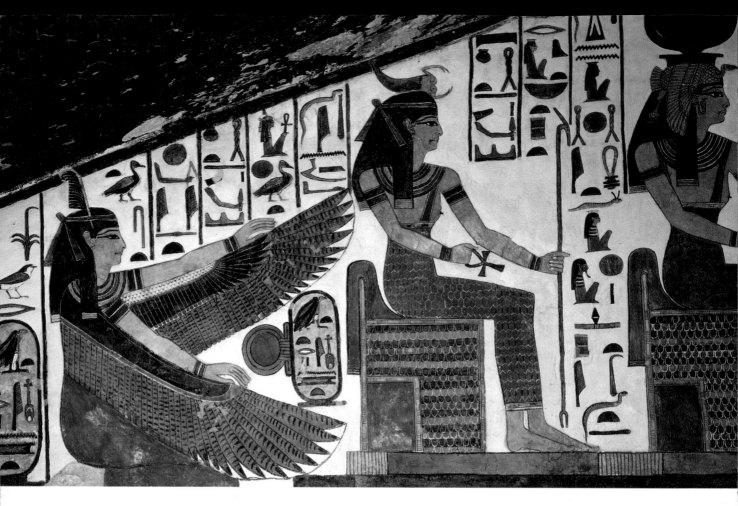

Ma'at, Serket, and Hathor on the east side of the descending corridor. Ma'at encircles Nefertari's cartouche with her outstretched wings.

The Descending Corridor

The second descent leads to the sarcophagus hall. The stairway is 7.5 meters long and drops nearly 3 meters over the course of eighteen steps. Down the midline runs a slip way for the sarcophagus.

The walls of this corridor form a parallelogram divided into two triangles whose long sides are actually a continuation of the floor level in Chamber C. Despite the awkward surfaces produced, not even the smallest area has been left undecorated. On each side is a narrow shelf about 4.5 meters in length and at the same level as the floor of Chamber C. Although the text and decoration offer no clue to its use, it could have served to hold ritual material or funerary furnishings.

The decoration in the upper triangles, those areas that lie above an imaginary plane extending out from the floor level of

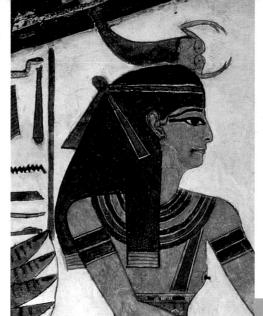

Detail of Serket, crowned with a scorpion, in the descending corridor.

Chamber C, is very much in keeping with what we have already seen. On the left, the queen presents two globular jars (*nemset* jars) held above an altar charged with fruit, vegetables, cuts of meat, and loaves of bread. Two smoking braziers perch on top. Beneath this cornucopia are a water jug and what may be a lettuce, an obscure reference to the god Amun. Wedged in are protective symbols denoting "protection, life, stability, dominion, all health, all joy, all protection like Re'."

There to receive the queen's offerings are three goddesses: Isis; her sister, Nephthys; and Ma'at, squatting with outstretched wings. The sisters are seated on imbricated throne bases, but only Isis wears a beaded dress. Nephthys is clothed far more simply in a green ankle-length shift. Ma'at is shown in a red dress, her green wings extended to shield the queen's cartouche. Next to it, a *shen* ring reminds us that the cartouche derives from a modified *shen* sign. Behind Ma'at and set apart from the scene by a narrow painted band is a partial titulary of the queen: "king's great wife, Nefertari, beloved of Mut."

Turning to the right, we find a nearly identical composition. Again, the queen presents two *nemset* jars, while two braziers blaze on an altar well laden with produce and bread but no meats. A more extensive version of Nefertari's name and titles is supplied in four columns of text just above her head. In the interest of presenting a more complete titulary, the artist had to forego Nefertari's tall, plumed ornament. A selection of amuletic devices fills out the composition.[8]

The recipients of Nefertari's largesse are a local form of Hathor, "she who is chief in Thebes," Serket, the scorpion goddess, and Ma'at. Both Hathor and Serket wear tight-fitting, ankle-length dresses with shoulder straps that expose their breasts.

BOOK OF THE DEAD

8 Here, the queen is called *"king's great wife, mistress of the two lands, possessor of charm, sweetness, and love, lady of Upper and Lower Egypt, the Osiris, Nefertari, beloved of Mut, justified before Osiris who resides in the West."*

But Hathor's green costume pales beside Serket's red, beaded dress.

Here, the cartouche behind Ma'at integrates well into the body of the text and does not seem an afterthought. All in all, the right-hand panel seems more carefully conceived and executed than the left. At the very least, the rhythmic alteration of color in the dresses introduces welcome variation. It is tempting to think that these differences reflect the work styles of two distinct artisan crews, the "right" crew a bit sharper aesthetically than their fellows across the corridor.

At the near end of each shelf (south thickness) is a representation of Serket (left) and Neith (right), similar to the door thicknesses of the recess upstairs. Only minor differences occur in dress and text. Amulets fill the space behind Serket. On the right thickness stands Neith, wearing

nemset *a globular jar used in rituals*

anklets in this instance. A row of amulets stands behind her.

At the far end of each shelf (north thickness) is a diminutive version of a *djed* pillar with two arms, each holding a *was* scepter. With the roof shelving rapidly downward, these *djed* pillars take on the aspect of squat, powerful braces supporting the roof.

The decoration on the lower portion of the descent contrasts starkly with what we have just seen. It is explicitly funerary and abounds with references to the netherworld. This is quite intentional, as we are for the first time literally passing below the floor level of the upper tomb. Henceforth, our progress is below ground in the figurative sense as well.

Except for minor variations, prompted mostly by spatial considerations, the decor on right and left walls is symmetrical. The left wall shows Anubis reclining on a shrine and Isis kneeling on the hieroglyph for gold. They make lengthy addresses to Nefertari. The black jackal god Anubis has a sash around his neck and a flail tucked behind his right haunch. The shrine is topped with a cavetto cornice and has a single door on its broad face.

Anubis makes two addresses, distinguishable by the different sizes of the hieroglyphs used. The first consists of twenty-nine vertical columns of increasing length that read from left to right. Immediately following, in slightly larger script, is a second address to the queen.9/10

A horizontal line at the base of each column separates these texts from those of

Looking back up the descending corridor toward Chamber C. The goddess Neith is on the south wall.

BOOK OF THE DEAD

9 The first statement: *"Words spoken by Anubis Imy-wt [he who is in (his) cerecloth], the great god who resides in the sacred land. I have come before thee, [oh] king's great wife, mistress of the two lands, lady of Upper and Lower Egypt, the Osiris, king's great wife, Nefertari, beloved of Mut, justified before Osiris, the great god who resides in the West. I have come before thee, and I have given thee a place that is in the sacred land, that thou mayest appear gloriously in heaven like thy father Re'. Accept thou the ornaments upon thy head. Isis and Nephthys have endowed thee and have created thy beauty like thy father, that thou mayest appear gloriously in heaven like Re', and so that thou mayest illumine Igeret with thy beams. The great assembly of gods on earth makes a place for thee. Nut, thy mother, greets thee just as she did Re'-Horakhty. May the souls of Pe and Buto make jubilation as [they did] for thy father who resides in the West. The great assembly of gods who are on [earth], they shall be the protection of thy limbs. Approach thy mother, that thou mayest sit upon the throne of Osiris. May the lords of the sacred land receive thee. May thy heart be forever joyous, [oh] king's great wife, mistress of the two lands, lady of all lands, Nefertari, beloved of Mut, justified before Osiris who resides in the West."*

10 The second statement: *"Words spoken by Anubis Imy-wt, the great god, lord of Ra-Stau [the necropolis]. I have come before thee, beloved daughter, king's great wife, mistress of the two lands, Nefertari, beloved of Mut, justified, and I have given [thee] the appearance of Re' in heaven that thou mayest sit upon the throne of Osiris. Approach thy mother, Isis, and also Nephthys. The great assembly of gods is [thy] protection forever and ever."*

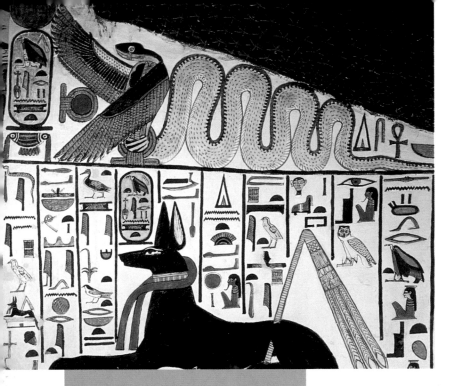

Isis, whom we see at the right. She is clothed in a red dress with shoulder straps and a white bag wig secured by a red fillet. Her iconographic signature is firmly atop her head. As she kneels forward, she places her hands above a *shen* sign. An outsize, highly detailed version of the hieroglyph for gold buoys her up. Beginning at the far left, in thirteen columns, Isis delivers the first of two speeches. In larger script, the second speech continues in ten columns.[11/12]

These scenes are duplicated on the right-hand wall of the descending corridor, except for minor adjustments in layout and text. The principal change is that, in place of Isis, it is now her sister, Nephthys, who kneels beneath Anubis. Considerable surface losses have obliterated much of Nephthys' speech.

Just beyond this, in the small triangle formed by the descending roof line and the scenes below, is a winged, coiled serpent with a *shen* sign around its stippled body and another just in front of the queen's cartouche. This elaborate monograph serves to defend the queen's person by vigorously protecting her name. The legend near the serpent's tail confirms: "She confers all life, stability, dominion like Re'."

At the very base of the stair and marking the passageway to the sarcophagus hall is a monumental door frame. Its jambs are decorated in outsize hieroglyphs presenting the name and titles of the queen. Although superficially similar to the upper door jambs, here, significantly, the queen is identified first and foremost as "the Osiris," an acknowledgement of her transformed state.

BOOK OF THE DEAD

11 The first speech: *"Words spoken by the great Isis, the god's mother, lady of heaven, mistress of all gods, who dwells in the sacred land. I have come before thee, king's great wife, mistress of the two lands, lady of Upper and Lower Egypt, the Osiris, mistress of the two lands, Nefertari, beloved of Mut, justified before Osiris, the great god, the lord of eternity. I have given thee a place in the sacred land in the presence of Wen-nefer. May thou appear gloriously like the Aten in heaven forever."*

Mention of the Aten at this time might have been fraught with meaning since the term was deeply implicated in the religious innovations of Akhenaten. But it is also the standard word for the sun's radiant disk and so occurs very early in Egyptian religious texts. In the context of a tomb already rich in solar imagery, its appearance here is not surprising.

12 The second speech: *"Words spoken with Isis, great mother, mistress of heaven, lady of all the gods. I have come before thee, great royal wife, mistress of the two lands, lady of Upper and lower Egypt, Osiris, Nefertari, beloved of Mut, justified before Osiris who resides in the West, the great god, lord of eternity. I have given thee a place in the necropolis so that thou mayest appear gloriously in heaven like thy father Re'. Igeret is illumined by thy beams."*

The lower west side of the descending corridor. Anubis is depicted as a jackal recumbent on a shrine. Above him, a winged cobra protects the cartouche of Nefertari.

The generous proportions and clarity of these hieroglyphs are exceptionally beautiful. Above them is a striking figure of Ma'at, who faces left with her left knee drawn up for support. The lintel text reads "words spoken by Ma'at, daughter of Re' (I) protect (my) daughter, the king's great wife, Nefertari, beloved of Mut, justified."

In this scene, it is easy to appreciate how deeply intertwined are Egyptian writing and art. Note that the head of Ma'at intrudes into the writing field precisely where Egyptian grammar requires a first person pronoun. Yet no such pronoun has been written; rather, Ma'at herself performs the task. This door frame is a masterpiece of calligraphy.

Isis, kneeling on the symbol for gold, rolls the sun disk, near the bottom of the west side of the descending corridor.

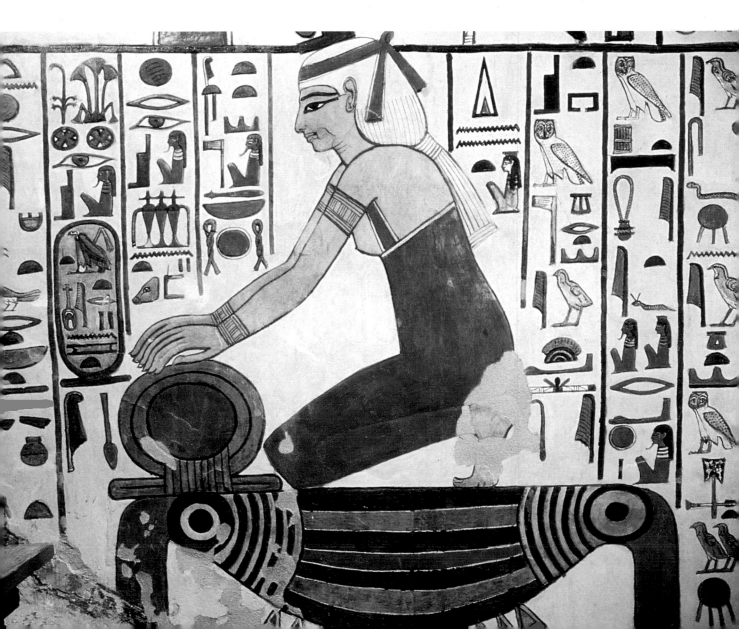

Door Reveal to the Sarcophagus Chamber

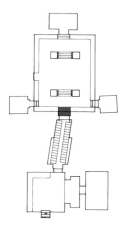

The little passageway to the burial cham-
ber, like the one above, is waisted; it has a
narrow outer dimension and wider inner
dimension. The outer thicknesses are deco-
rated identically, or nearly so. Figures of
Ma'at, with the feather of truth tucked into
her headband, welcome the queen.

The inner thicknesses reassert the
mythic orientation of the tomb by featur-
ing Nekhbet, the serpent of Upper Egypt
(south), on the left and Edjo of Lower
Egypt (north) on the right. Nekhbet wears
an *atef* crown and Edjo the double crown.
We proceed "west," into the netherworld.

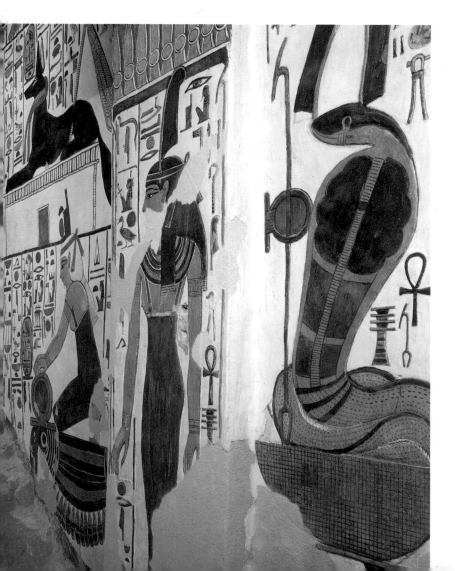

*Nekhbet, wearing the
two-feathered* atef
*crown, on the west side
of the passageway to
the burial chamber.*

Opposite:
*The entrance to the
sarcophagus chamber.
Ma'at with wings
outstretched welcomes
Nefertari from the
lintel.*

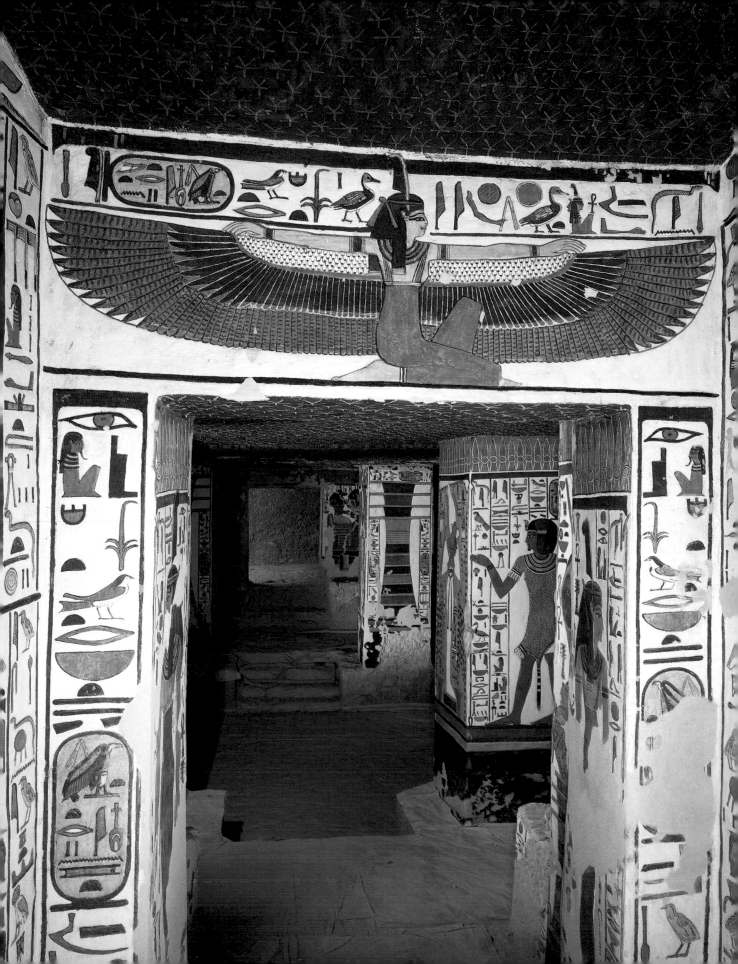

Chamber K

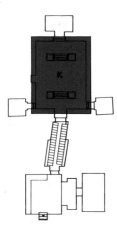

The dimensions of the sarcophagus chamber (Chamber K) are 10.4 meters deep by 8.2 meters wide. A low bench, probably another place to put funerary equipment, runs along the chamber's perimeter. From the scanty bits of inscription still adhering to the ends of the bench, we can discern mention of the queen as an Osiris.

Above the bench, the walls of the chamber are decorated with long scenes forming, with one exception, an integrated composition. The left side of the chamber provides illustrations and texts from Chapter 144 of the Book of the Dead; the right side, illustrations and texts from Chapter 146. Each is a description of the domain of Osiris.

The queen here demonstrates her profound knowledge of this secret realm by naming the doors and their attendants, so documenting her fitness to reside with the immortals. Chapter 144 describes the gates and Chapter 146 the portals of this world. Framing the compositions are a stippled band, *kheker* frieze and sky sign above, alternating bands of red and yellow ochre below.

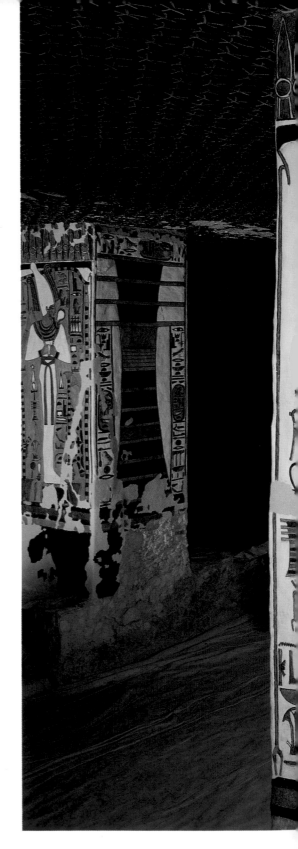

View looking northeast into Chamber K. On the west face of Pillar 1, Nefertari is welcomed by Hathor of Thebes.

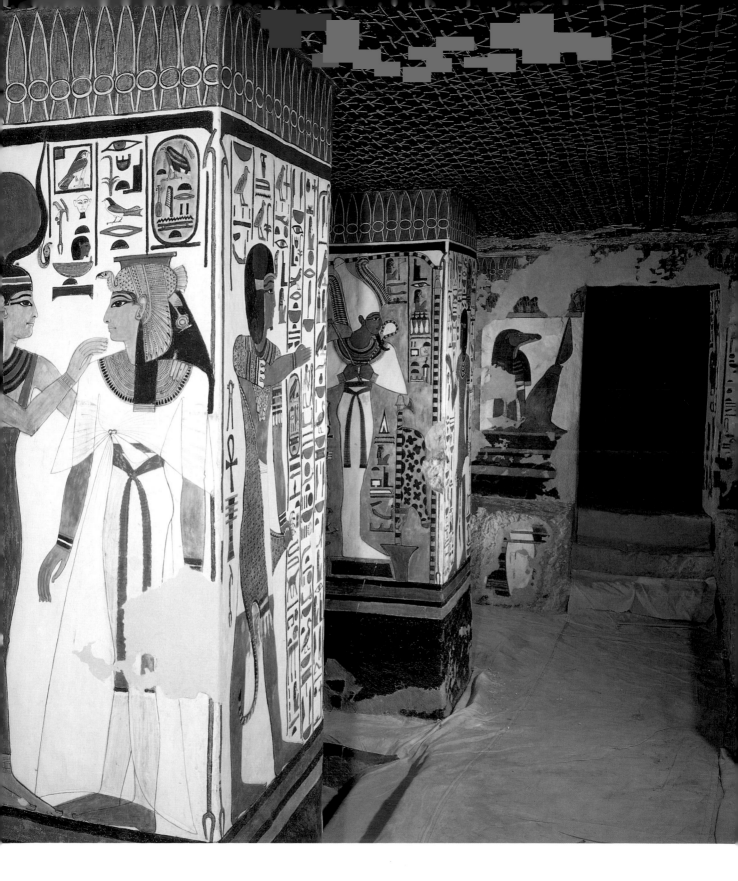

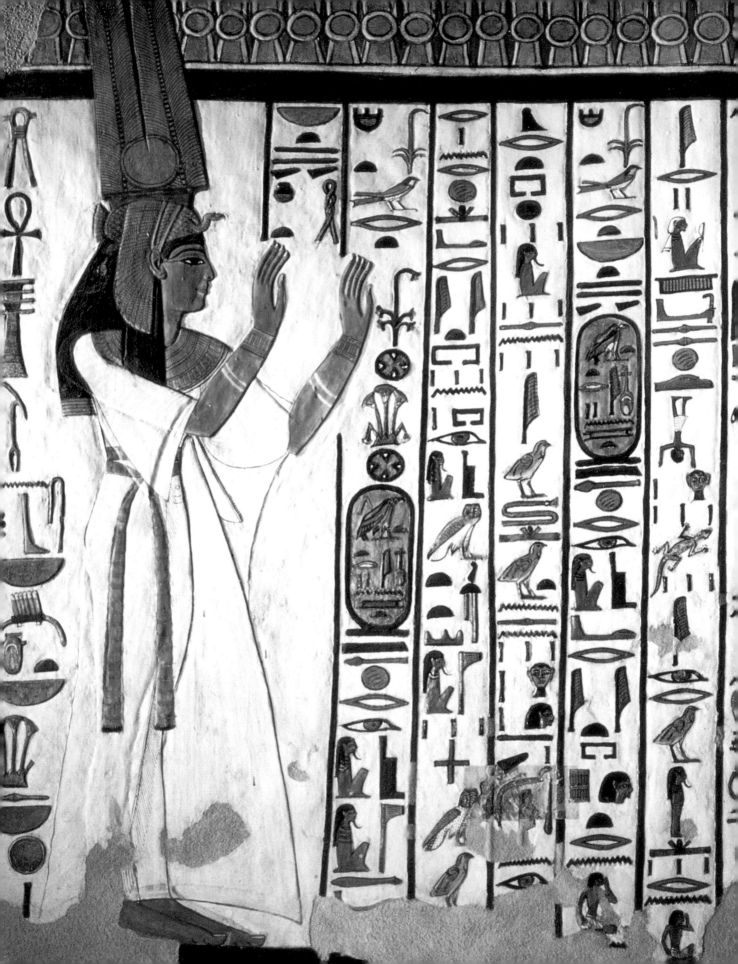

Left/West Side of Chamber K

The composition begins on the south wall, west section, with a magisterial full-length view of the queen, who lifts her hands in adoration before a trio of formidable *demiurges*. She is dressed in a white full-length pleated robe and her crown of choice. Her name and titles fill two columns immediately in front of her. A broad expanse of variegated hieroglyphs separates the queen from the first gate and its attending genii.

There are seven gates in Osiris' realm; five of which are here described and illustrated. Throughout the composition, the order remains constant: text first, gate second, attendants third. Each gate is composed of an ochre surround and a red door. By Egyptian color conventions, this is shorthand for wood. The three attendants at any single gate are its keeper, guardian, and announcer. This trio is invariably composed of three anthropomorphic gods, the first ram-headed, the second animal-headed, the third human-headed. The first figure is always male. Each carries particular attributes: a leafy sprig, a knife, an *ankh* sign. Yet there is no obvious correspondence between their names and their representations.

By enunciating their names, the queen demonstrates her power over these potential adversaries. She may then approach the gate, recite a prayer, and pass on to the next.[13]

The first gate scene forms too large a composition to fit entirely on the south wall, and so portions of it had to be carried over onto the west. The balance of the scene, the door and guardians, ends precisely at the left door jamb of the small annex (Chamber M).

With the right jamb begins the text for the second gate, the best preserved of the five. Its seventeen lines — in reverse order as they are in the first gate — are well preserved and thoroughly legible.[14]

demiurge a lesser god, subordinate to greater divine beings or to a supreme deity

Opposite:
Nefertari with her hands raised in prayer on the west side of the south wall of Chamber K.

BOOK OF THE DEAD

13 At the first gate, Nefertari intones: *"The first gate. The name of its keeper [is] 'downward of face, numerous of forms'; the name of its guard is 'the burning of ear' [eavesdropper], and the name of its announcer is 'penetrating of voice' [loud]."*

14 At the second: *"Second gate. The name of its keeper [is] 'he who opens their foreheads.' The name of its guardian, 'virtuous of countenance.' The name of its announcer is 'Imsus' [the burner?].*

After appropriate identification is provided, Nefertari speaks: *"Do not be weary when the old ones justify the living secrets anew in their years. The Osiris, the king's great wife, mistress of the two lands, Nefertari, justified before Osiris, rich in offerings of the moment, who makes his [sic] way with a flame, who defeats foes. The Osiris, the king's great wife, mistress of the two lands, Nefertari, beloved of Mut.*

I have prepared a path. May you permit me to pass. Protect me that I may see Re' traverse it among those who make offerings to the Osiris, the king's great wife, mistress of the two lands, Nefertari, beloved of Mut, justified. I have prepared a path that you might let me pass. Protect me, in order that I may see Re' traverse it."

Again, improper use of masculine parts of speech in reference to the queen is simply a grammatical lapse by the copyist.

The meaning of the text is opaque; but its vignette, one of the best preserved in the sarcophagus chamber, is clear. A male god with ram's head is the keeper, a lioness with twin snakes sprouting from her head is the guardian, and the announcer is a male deity. The males wear green vests held in place with shoulder straps and a knot of Isis at the navel. They have ruddy skin while the female god has a light complexion. This distinction between male and female skin tones is a common convention.

The text and vignette of the third gate have suffered quite substantial losses but from vestiges of text and outside sources, the names of the three attending gods are recoverable.[15]

Note that the texts of Gate Three and subsequent gates appear in normal order. They are no longer reversed. This reorientation of hieroglyphs is not observable on the opposite side of the burial chamber.

It may be significant that we have just reached the mid-point of the chamber, directly above the niche for the canopic chest, where the queen's embalmed viscera were stored and where the foot of her sarcophagus once rested. This point is the architectural and religious focus of the tomb; so the hieroglyphs have been adjusted to focus our attention on this central verity: the queen's sarcophagus.

The entire text and doorway constituting the fourth gate is obliterated, up to the northwest corner of the room. Its triad of gods appears on the north wall, facing our left. They are damaged; but enough remains to verify that these were male deities: ram-, antelope-, and human-headed.

The fifth gate's text and illustration follow. For want of space, however, the artist had to reduce the usual complement of door attendants to the ram-headed keeper alone. Nonetheless, the names of all three are preserved.[16]

15 At Gate Three, the doorkeeper is *"the one who eats the excrement of his hinderparts"*; the Guardian is *"vigilant"*; the announcer is *"he who curses."*

16 At Gate Five, the keeper is *"he who eats snakes"*; the guardian is *"the burner"*; the announcer is *"Hippopotamus-faced, raging with power."*

BOOK OF THE DEAD

Opposite:
The keeper, guardian, and announcer for the second gate on the west wall, Chamber K.

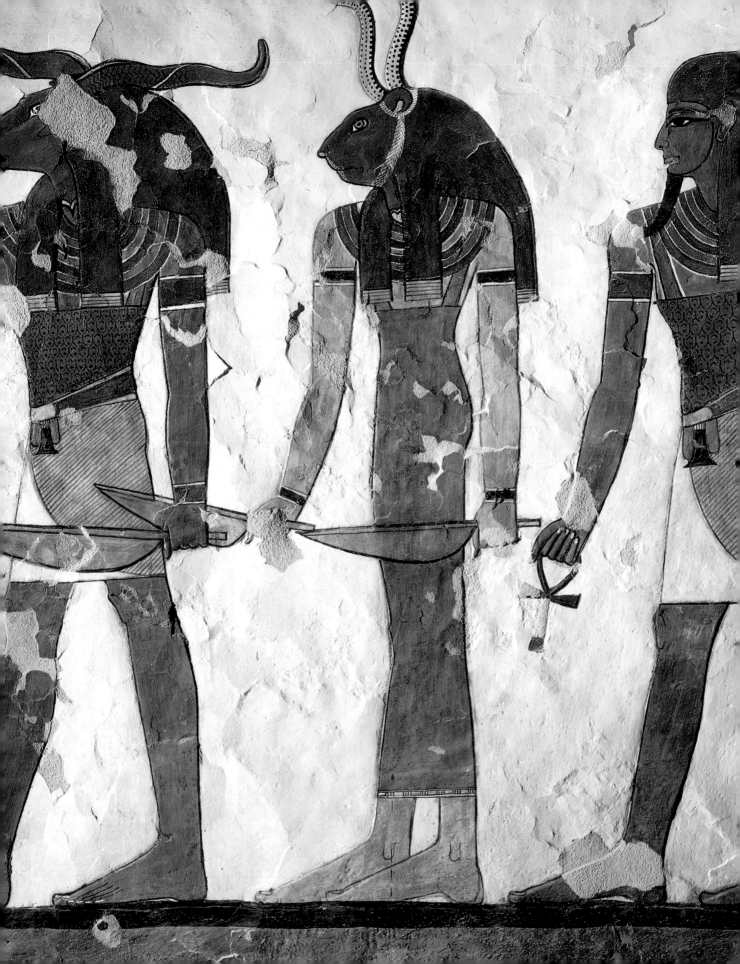

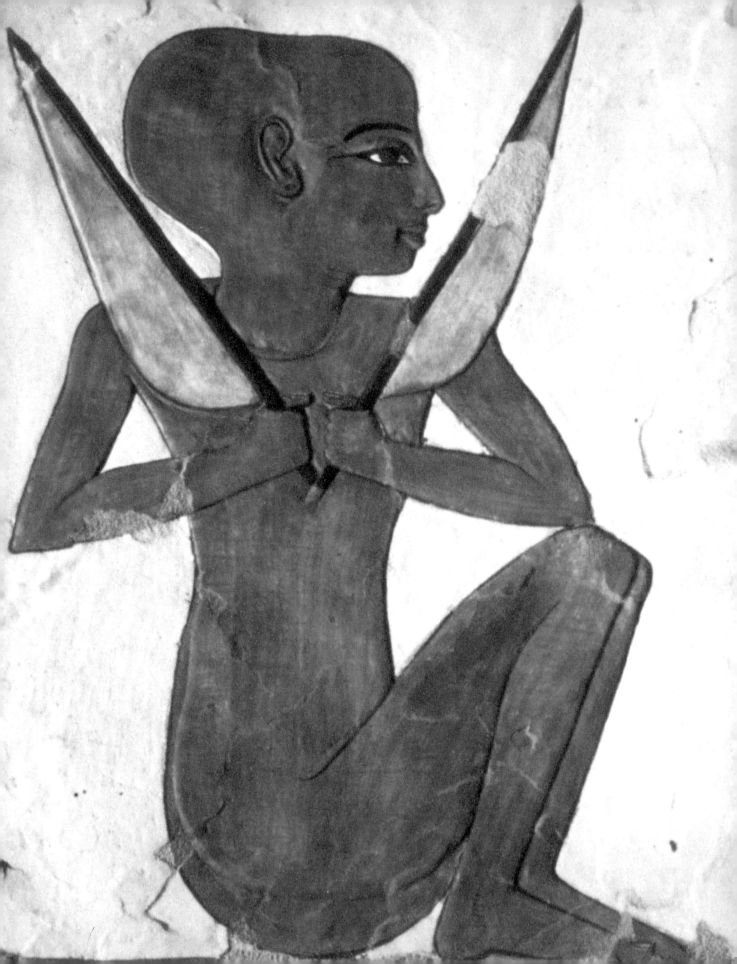

Right/East side of Chamber K

Chapter 146 of the Book of the Dead provides Nefertari with the means to pass successfully through the twenty-one portals of the domain of Osiris. As in Chapter 144, it is crucial that she possess knowledge and be able to name the portal and its keeper, who blocks her passage.

Of the twenty-one portals, only ten are mentioned in the tomb. Text and vignette are fully integrated, as they would have been in a funerary papyrus. Each section shows a stylized portal consisting of door jamb and *uraeus* frieze, within which squats the figure of the keeper. Though we cannot be sure, it is likely that all the keepers held knives; they are quite prepared to bar the queen's way if necessary. The texts accompanying these illustrations are short, usually comprising only four or five vertical columns. They appear in reverse order throughout and always follow the illustration, the opposite of Chapter 144, on the facing wall.

The east wall of the chamber has endured considerable damage. Some sections are difficult to read and some have disappeared entirely. As before, the initial scene appears on the south wall.

Above the rock bench, the queen appears in a pleated white gown. Her hands are raised before the first portal and its vulture-headed keeper. Substantial loss of wall surface has reduced the text to fragments. Nefertari asserts that she has made no transgression along the path to the "west," so justifying her arrival at this point in her journey.[17]

Opposite:
The knife-wielding
doorkeeper for the
fifth portal on the
east wall of the burial
chamber.

BOOK OF THE DEAD

17 From various sources, we can restore the first portal text. Its name is *"Lady of fear, lofty of battlements, the destroyer, who wards off storms and who rescues the plundered." The name of the keeper is "Dread."*

18 The first three columns, from left to right, provide the second portal's name and its keeper: *"Mistress of Heaven, lady of the two lands, she who licks [her calves], mistress of all mankind, who numbers [men]." The doorkeeper is "who fashions [the end]."*

At the wall juncture is the second portal, whose keeper has the head of a mouse. The two columns of text behind belong to the inscription on the adjacent wall, between the entryway to the eastern annex and the wall juncture.[18] Curiously, the artist has immediately duplicated the second portal text to fill the corner juncture and the small space behind the mouse-headed doorkeeper. Such replications—or dittographies—are not uncommon and seem to act as space fillers.

Stepping across the annex opening, we approach the third portal and its keeper, a crocodile clutching a large knife. The vestigial text identifies the portal as "mistress of altars, great of offerings, who pleases every god on the day of faring upstream to Abydos." This reference encapsulates the wish of every Egyptian to make—either in fact or symbolically—a waterborne journey to Abydos, the traditional home of Osiris. The name of the doorkeeper is "the brightener, friend of the great god who sails to Abydos."

The keepers for the
third, fourth, and fifth
portals on the east
wall of Chamber K.
The text pertaining to
each of the portals
follows the
representation.

Following page:
The north wall of
Chamber K. Anubis,
the god of embalming,
Hathor, the funerary
goddess, and Osiris,
mummified, receive
adoration from
Nefertari.

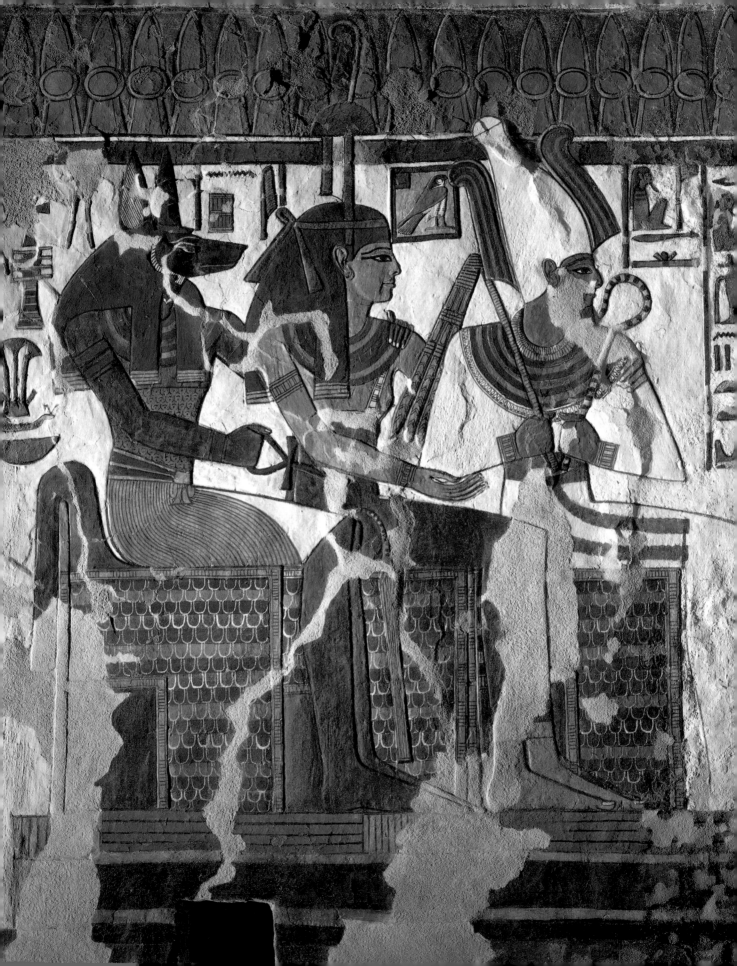

The fourth portal has a bull as its keeper. The name of the keeper is "the long-horned bull," providing in this one instance a satisfying correspondence between the keeper's name and face.[19]

Perhaps the oddest figure in this panorama of the inhabitants of Osiris' realm is the doorkeeper for the fifth portal: a nude, squatting child with distended cranium. He wields two knives, which he carries crossed in front of him. The artist, perhaps feeling a need to expand the interval between this portal and the following, has duplicated the last one-and-a-half columns of text, another instance of dittography.[20]

Portals Six through Eight occupy the north half of the east wall and are badly defaced. We can discern the serpent-headed keeper of the sixth portal, but both its name and the keeper's have vanished. Portal Seven is all but obliterated.[21]

Only the *kheker* frieze and a band of rampant *uraei* remain from the eighth portal. Of its text, only two words remain. One word is, however, diagnostic (*mty*: "engenderer"), suggesting that the artist placed the ninth portal text with the eighth portal, so compounding his earlier mistake. Perhaps the copy book was defective at this point. Of the ninth portal, its keeper, or identifying legend, no trace remains.

The tenth and final portal appears on the north wall of the sarcophagus hall. Rather better preserved than the previous three, this portal is clearly guarded by a crocodile-headed keeper.[22]

Following immediately, a large composition occupies the rest of the north wall and ends at the doorway to the northern annex. It shows the queen rendering homage to three seated gods. The queen faces to our left, while the three seated gods face right. They are Osiris, Hathor, and Anubis.

BOOK OF THE DEAD

19 The fourth portal's name is *"mighty of knives, lady of the two lands, destroyer of the enemies of the weary of heart, who is wise and free of wrong-doing."*

20 The fifth portal is identified as *"mistress of lower Egypt, the joyful, for whom one makes requests without entering in against her."* The doorkeeper is *"who commands the opponent."*

21 The text associated with Portal Seven is mistakenly drawn from Portal Eight. Nearly half of it survives, permitting us to reconstruct a part of its name as *"the kindler of flames, who is hot, slayer of…, grinder of those who do not…"* The doorkeeper is *"who protects his body."*

22 The tenth portal is called *"Loud of voice, who awakes with shouts, who laughs at dread [?], greatly esteemed, fearful for those within it."* The name of the doorkeeper is *"the great embracer."*

Osiris is shown mummiform, wearing the *atef* crown and carrying his usual regalia. Seated behind him, Hathor has on her head the symbol for the "west," to signify her association with the necropolis. Following her is the jackal-headed Anubis, god of embalming and Osiris' son by Nephthys.

The crocodile-headed keeper of the third portal. Chamber K, east wall.

The Canopic Niche

Descending a flight of four steps, we find ourselves in a depression that once held the queen's granite sarcophagus. From this vantage, the sides of the stone bench are readily visible. The plaster decoration has peeled off in most places, but enough remains to reconstruct in the mind's eye a decorative band of alternating pairs of *djed* pillars and *tyet* amulets, respectively evoking the memories of Osiris and of Isis.

Along the west wall, in the middle of the bench, a small niche has been cut. About one meter square, it probably held the canopic chest, a small coffer containing the queen's embalmed viscera. The niche is decorated on its three inner surfaces.

On the south (left) side, the decoration shows three mummiform figures: Imsety, Anubis, and Qebehsenef. The latter is shown with human head, even though he customarily was given a falcon head. Each is called "the great god."

At the back of the niche is an image of the winged goddess Nut, mother of Osiris and Isis. Her wings are at her sides, and in each hand she holds an *ankh* sign. Nut directs her words to the queen.

Less well preserved is the right side of the niche. It shows faint traces of three mummiform figures. Respectively, they bear baboon, jackal, and perhaps falcon heads. Also designated great gods, these are Hapy (baboon), Duamutef (jackal), and Anubis (falcon). The four genii in the niche are the sons of Horus, whose principal role in the funerary cult is to protect the queen's organs.

Note that the subdued treatment of these scenes contrasts sharply with the brilliant polychromy in the rest of the tomb. Instead of colorful sculpted plaster, here we find simple line drawings executed in yellow. The details of costume, done in yet darker yellow, stand out against the light yellow of the body.

tyet a kind of knot, a variation on the *ankh* symbol. The *tyet* knot is a sandal strap seen with the loops turned downward

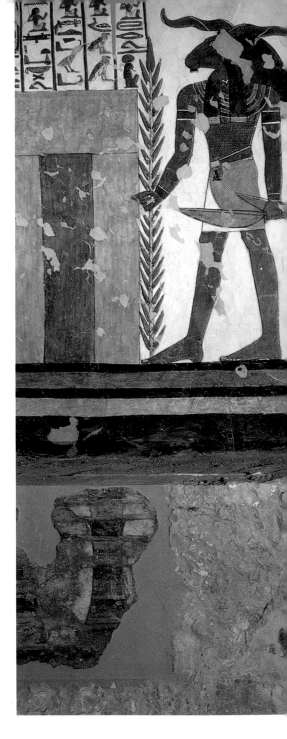

The small niche cut into the west wall of the burial chamber probably held the canopic chest containing Nefertari's embalmed viscera.

The style of the scenes in the niche suggest that the decoration was executed a generation after the tomb was closed.

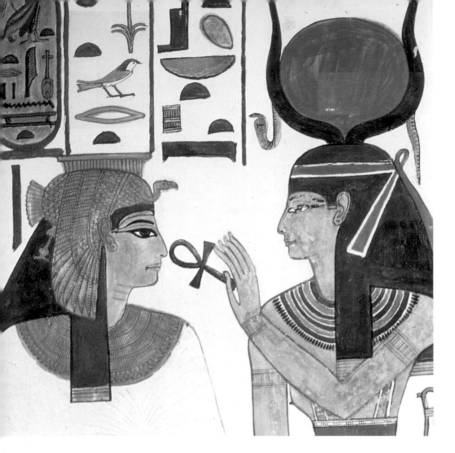

dado a decorative band running around the base of a wall distinct from any scene above

The east face of Pillar II in Chamber K. The goddess Isis extends the ankh *to the nose of Nefertari, giving her the breath of life.*

The Pillars and Burial Depression

The placement of the actual sarcophagus in a shallow depression has architectural and religious significance. It focuses the eye and symbolizes the ground-based reality of death. The depth of the cutting is some 40 centimeters below the pavement.

The space is defined by four pillars, hewn from the living rock. Their inner faces are flush with the cutting and extend to the floor of the depression, so reinforcing their function as roof supports. They also serve as metaphors for the four supports holding aloft the canopy of the heavens.

The sixteen faces of these pillars form a body of work that is among the finest in the tomb. Their decoration is highly programmatic and sets out in detail certain key ideas. Each of the sixteen compositions on the pillar faces is framed by *kheker* friezes above a sky sign. *Was* scepters mark the edges, and a *dado* of red and yellow ochre marks the bottom.

The tomb's major and minor axes intersect between the pillars and are rigorously defined by the decoration. On the inner column faces of the minor axis (west-east) are *djed* pillars. On the inner column faces of the major axis (north-south) are figures of Osiris facing south, toward the tomb entrance. He is thus looking from the "west," waiting to welcome Nefertari into his sacred abode.

On the southern pillars, as if pointing the way to the central corridor between them, are images of the Iunmutef Priest (left) and Horendotes, the "avenger of his father" (right). The Iunmutef Priest is dressed in a splendid white kilt, broad collar, arm bands, and wristlets. His wig is kept in place by a fillet with golden *uraeus.*

But the most sumptuous item of his apparel is the leopard skin slung over his right shoulder, the leopard's head resting upon his breast. This is the dress of an officiating priest. With his left hand, he holds the animal's left rear paw. With his right arm raised, he gestures to the avenue between the columns, urging that Osiris act on behalf of Nefertari. The priest's words, in six columns reading from right to left, are addressed to his father Osiris, who faces him on the adjacent pillar face.[23]

One sign group occurs twice, at the bottom of Column Two and again, redundantly, at the top of Column Three. Amuletic devices behind the priest signify protection, life, stability, and dominion. The Iunmutef Priest, literally "the pillar of his mother," represents the young Horus, who protected his mother Isis in her hour of need, so fulfilling the role of a dutiful son.

Looking northwest through the burial chamber. Horus appears on the south face of Pillar 1 in the form of Horendotes officiating as a priest.

23 *"Words spoken by Horus, the pillar of his mother (Iunmutef). I am thy beloved son, [oh] my father Osiris, I have come to greet thee. Four times forever have I beaten thy enemies for thee. Mayest thou cause thy beloved daughter, king's great wife, mistress of the two lands, Nefertari, beloved of Mut, justified, to rest within the assembly of great gods who are in the entourage of Osiris, whom all the lords of the sacred land join."*

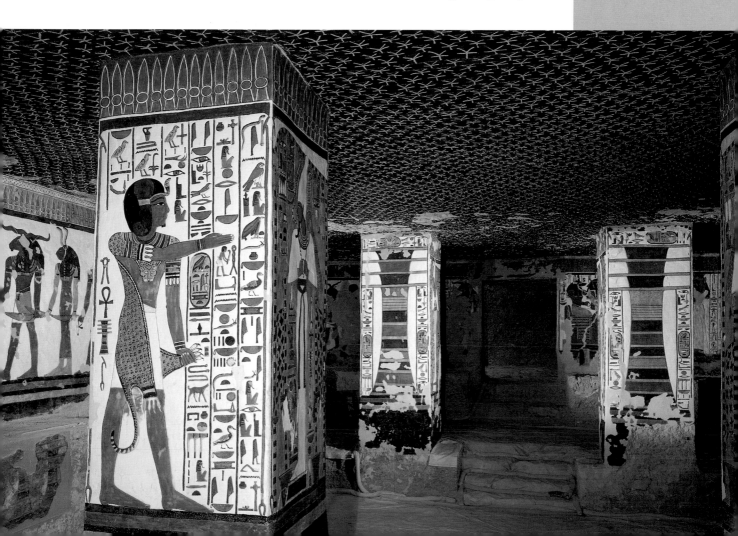

A similar chord is struck by the analogous composition on the southeast (right) pillar. The officiant, another priest, similarly dressed, his right hand raised in a gesture to mark his utterance, faces to our left. This priest is identified as Horendotes, "the avenger of his father," who redressed the wrongs suffered by Osiris at the hands of his evil brother, Seth.

Horendotes' words, also directed to a figure of Osiris on the adjacent pillar face, read in six columns from left to right. Behind this figure are the amuletic devices for protection, life, stability, dominion, all health, all his guarding. [24]

Passing between the pillars, we encounter two of the four images of Osiris in the vicinity of the sarcophagus. The compositions are nearly identical. Sheltered by a yellow kiosk with arched top, the mummiform Osiris stands on a low dais. Atop his head, the *atef* crown; in his crossed arms, the regalia of crook and flail. His skin is green. A red sash wraps around his waist. Either side of the dais is the Anubis fetish: a staff with leopard skin stuck in a mortar.

In both scenes, Osiris is identified as ruler of the assembly of gods. In a single column of text before each figure are Osiris' promises to the queen. On the left, he gives her the appearance of Re'; on the right, he assures her a place in the sacred land.

Moving to the intersection of the avenues between the pillars, we see at a glance that the column faces all bear representations of the *djed* pillar, symbol of Osiris. But this figurative motif also serves to underscore the stone pillars as the literal supports of the roof above our heads. The *djed* columns are sized to fit exactly within the rectangle of the column face, their tops and margins defined by versions of the queen's titulary. But for minor variations in spelling, these inscriptions are the same. The edge texts always point outward; while the upper text always faces inward, toward the sarcophagus.

Proceeding farther northward, we meet the second pair of Osiris figures, again facing the entrance of the tomb. Like the earlier two, these Osiris figures stand in yellow kiosks. Both are dressed as before and flanked by the Anubis fetish. On the left, Osiris is identified as King of Eternity; while on the right, he is called Lord of the Necropolis. Since death, like eternity, endures forever, these formulations are equivalent. Before Osiris, in a single column of text, is his promise to Nefertari: assurance of a place in the sacred land forever and ever.

Chamber K, the east face of Pillar IV. Anubis, depicted as a standing man with a jackal head, has one hand on Nefertari's shoulder.

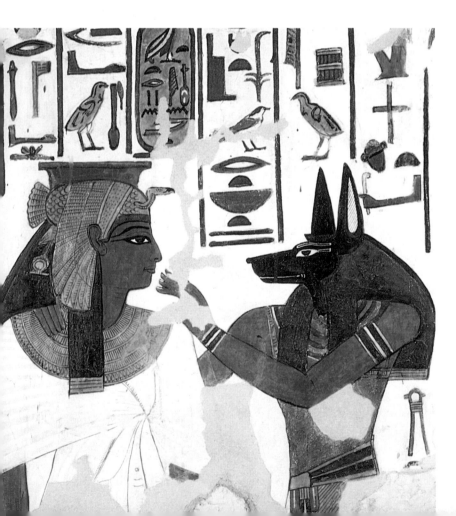

Once outside the area bounded by the pillars, we find that the decorations of their outer faces exhibit more variety. On each, the queen is welcomed by a protective god or goddess: thrice by Isis, twice by Hathor of Thebes, and once by Anubis. As ever, the queen wears her pleated white gown and broad golden collar. Her vulture cap head-dress is common to all images of Nefertari; but here it lacks the high, twin plumes, which could not be accommodated while still displaying the queen's titulary.

The north face of Pillar III in Chamber K, showing Nefertari with Hathor.

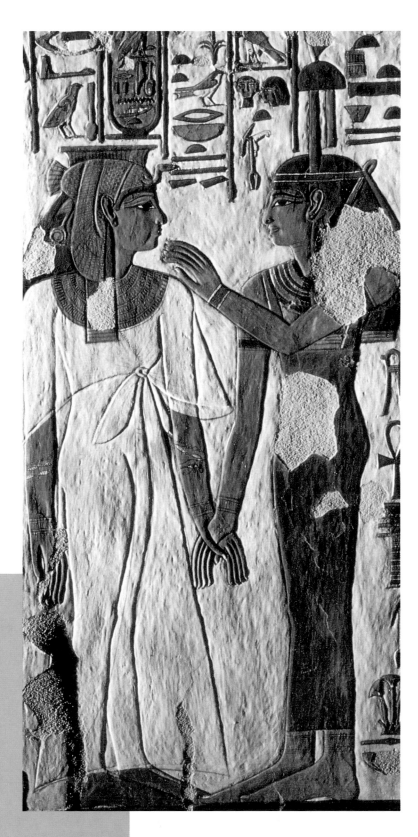

24 BOOK OF THE DEAD
"Words spoken by Horendotes. I am thy beloved son, who issues forth from thy loins. I have come to knit for thee thy limbs and I have brought thee thy heart, [oh] my father Osiris who resides in the West. Mayest thou allow the king's great wife, mistress of the two lands, Nefertari, beloved of Mut, and the great divine assembly to be joined with those in the Necropolis."

The Annexes
(Not Open to the Public)

Three small rooms issue from the sarcoph-agus chamber: one to the west (Chamber M), another to the east (Chamber O), and a third to the north (Chamber Q). Their decoration has suffered badly. The east and west chambers are square, about the same size: 2.3 meters to the side. The northern annex is a rectangle of 3.6 x 2.1 meters.

Of the three, the decoration in Chamber M is best preserved and of real interest. The doorway is marked by images of the cobra goddesses of Upper and Lower Egypt. On the right is a serpent coiled upon a basket resting on twin *djed* pillars. She is identified as Nekhbet, yet wears the red crown of Lower Egypt. On the left, a similar scene; but of Edjo, wearing the double crown, red and white, of United Egypt. As Edjo should be wearing the red crown and Nekhbet the double, there is clearly some confusion here. On the door's inner thickness is space for a single column of text with the queen's titulary.[25]

The inner face of the door frame has two scenes. On the left, to the north, Osiris, as the *djed* pillar, holds *was* scepters and has *ankh* signs on his wrists. The right scene, to the south, is much narrower and is the sole representation of the queen as a mummy. She is swathed in red, with wig, broad collar, and vulture cap.

The scenes on the left and right walls form a pair: the four sons of Horus, together with Isis and Nephthys, welcome the queen. In squatting posture, Imsety, Duamutef, and Isis are on the left. Hapi,

Qebehsenef, and Nephthys are on the right. The queen passes through this protective defile to reach the principal scene in Chamber M, on the back (west) wall, a curious depiction of the mythic home of Osiris in Abydos.

Enough of the scene survives to read it clearly: a wide booth or temporary struc-ture erected on five supports, each bearing a column of text. In the shallow, gabled pediment above are opposed, undulating serpents whose protective wings meet in the center. In the intervals between the supports, from left to right, are Thoth, Anubis, Imsety, and again Thoth. In front of each, on a standard, is a symbol of the night sky. Each column of text is the utter-ance of one of these gods on Nefertari's behalf.

The eastern annex (Chamber O) is framed by a doorway decorated exactly like the one of Chamber M, except that the artist has now correctly linked Edjo with the red crown. The inner thickness also mentions the queen's titles. The panels either side of the inner door frame have *djed* pillars; but the left (south) panel is a symbolic representation of the queen, a complement to the image of her mummy in Chamber M.

The scenes in this chamber are less well preserved, but the queen is twice shown in adoration. On the left, she raises her arms in praise of Hathor, whose frag-mentary image shows her in the aspect of a cow, mistress of the "west" and patron of the Necropolis. An altar graced with flow-ers separates the queen from the goddess.

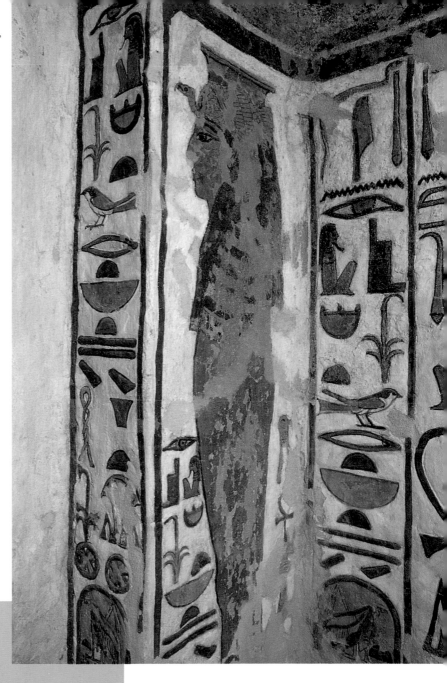

On the right, the queen stands before enthroned images of Anubis and Isis. Another altar, this time laden with stylized loaves of bread, stands before the queen.

On the rear wall is a much-damaged image of Ma'at with outstretched wings, facing to our right. Enough remains of her utterance to the queen to proclaim that she has given Nefertari the lifetime of Re' and a place in the House of Amun, in other words, Karnak Temple. Perhaps a statue was erected there to the queen's memory.

The decoration in the north annex is largely obliterated. Paired serpents guard the door thicknesses. A solitary figure of Isis on the south wall is all that remains on the west side of the room, along with a small area of plaster bearing the queen's cartouche on the north wall. A vestigial procession of gods fills the right wall. Among them, we recognize Serket preceded by two male deities. An image of the *djed* pillar between two *tyet* knots, reminiscent of the decorative border around the sarcophagus chamber, takes up the south wall, east section.

BOOK OF THE DEAD

25 The right is destroyed, but the left reads: *"the Osiris, the king's great wife, mistress of the two lands, lady of Upper and Lower Egypt, Nefertari, beloved of Mut, justified before the great god."*

Nefertari in mummified form in the southeast corner of Chamber M.

The present condition of the wall paintings
in the tomb of Nefertari demonstrates
the crucial work of the Getty Conservation Institute

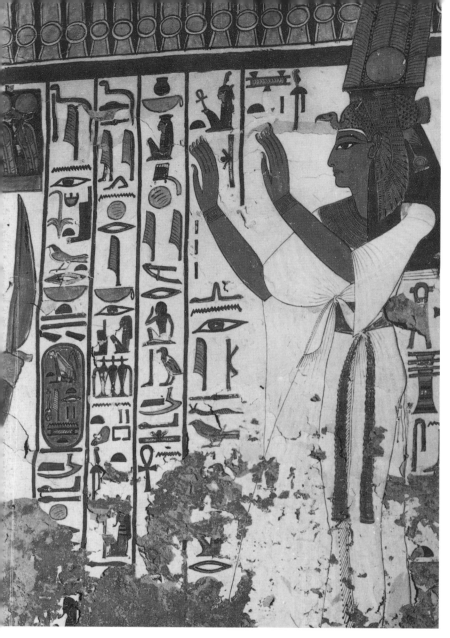

in conservation and preservation of our common cultural heritage throughout the world.

In an age of ever increasing, ever less nourishing distractions, the world's cultural heritage provides spiritual sustenance for all humanity. Heritage links us to cultures of the past and enriches the times in which we live.

A world without a cultural memory, without the capacity to experience the authentic, the genuine, is a world profoundly deprived. Without our cultural heritage, we are like people without memory: we have no way of knowing where we came from, where we are going. We simply live inexplicable, incomprehensible, isolated moments.

The Getty Conservation Institute strives to preserve this heritage by undertaking collaborative conservation projects in countries as diverse as China, Ecuador, Tanzania, and the United States, always in partnership with host authorities. In the conservation of the tomb of Nefertari, the GCI worked with the Egyptian Antiquities Organization, since renamed the Supreme Council of Antiquities. The Council is responsible for some of the richest and most ancient cultural heritage sites in the world. In terms of sophistication, power, and enduring glory, the heritage of very few other nations can rival, much less surpass the splendor of Egyptian culture,

Close-up view showing salt crystals capable of prying the paint layer away from the plaster.

reflected in these majestic monuments. Moreover, in Egypt, further magnificent discoveries are even today being made.

The Council is committed to conserving and preserving this inestimably valuable cultural heritage on behalf of all the peoples of the world. That is one reason why the GCI first undertook the joint effort at the tomb of Nefertari. In all of its projects, the GCI seeks sustainability, where the collaborative conservation achieved will be maintained by its partners in the host country.

The issues of conservation of cultural heritage are complex, multifaceted ones that seldom lend themselves to simple or obvious solutions. Aside from the scientific and technical aspects of conservation in the management of heritage, multiple values must be weighed: cultural, spiritual, educational, interpretive, economic. For example, the revenue gained by admission of tourists to the tomb of Nefertari may accrue to the benefit of countless other Egyptian sites in need of conservation, maintenance, and management.

Yet, visitors pose a risk to the paintings in the tomb. After all, however lofty an aesthetic and cultural achievement, the tomb is basically a cave. A blind hole, with only one entrance/exit. Without sophisticated climate-control equipment, conditions inside the tomb are subject to extreme, abrupt alterations when visitors enter. Thus, a balance must be struck between the number of visitors allowed to enter the tomb and the economic benefit resulting from their entry, as well as the educational and aesthetic benefits derived by those who personally experience its splendor.

An exact replica of the tomb, a "virtual experience" museum in close proximity

Chamber K, east side of the south wall, showing the deterioration that occurred between 1904 (opposite) and 1989.

Photo opposite: Courtesy of the Museo Egizio, Turin.

Visitors waiting to enter the tomb after it was opened to the public in November 1995.

Photo: Shin Maekawa.

Detail from the east wall of Chamber K circa 1920 and 1989.

Top photo: Courtesy of the Museo Egizio, Turin.

to the actual tomb, could provide an alternative if tourist pressure becomes too great. Such a solution has met with great success at the site of fragile, paleolithic cave paintings in Lascaux, France.

Critical to finding the balance is continued monitoring of the environment within the tomb itself. The current system for climate control at the tomb of Nefertari —a tube and fan that serve to pump humid air out of the tomb and suck in external air—is rudimentary. The air introduced is unfiltered and from time to time may be laden with microscopic dust particles borne on the desert winds. These particles settle on the floor of the tomb, but also, over time, adhere to the walls, obscuring the brilliance of the painting.

The GCI is employing solar-powered sensors to ensure constant measurements. Without such constant and precise monitoring to direct decision-making, the risk of deterioration will not only remain, it will increase. Irreversible damage will certainly occur.

Damage by moisture, particularly the activation of salt leached from the limestone mother-rock and plaster of the tomb, is cumulative. At a certain point, such cumulative damage to the paintings reaches a point of no return. At that time, the only remaining option might be restoration. And restoration is fake.

By contrast, conservation deals with the authentic creation that yet remains. The conservators' art and science apply to these precious artifacts of our common cultural heritage only those methodologies that take the "patient" as it is. No one can rejuvenate it, re-create it, restore it. Even to try is sheer artifice.

Thus, to make successful use of all the potential values and (sometimes conflicting) benefits of a cultural heritage as

vast and rich as that of Egypt, it is essential that attention be concentrated also on management and custodianship. Only in this way can we be certain that a site is neither destroyed nor degraded in its authenticity.

Conservation of such treasures can be more than cost effective, provided that the management is properly undertaken and wisely administered. For example, display in the Egyptian Museum of pharaonic mummies, using GCI-designed, nitrogen-filled cases, has proven exceptionally successful. Today, the necessary mechanisms, techniques, site-management plans, and methodologies are available. Sometimes lacking are administrative and political will.

All these are aspects of the present and future that concern the GCI, as well as the Egyptian authorities. The past traumas of the tomb have been arrested. Together, we have managed to halt previously inexorable processes of destruction. Now the challenge is to maintain a healthy equilibrium, both in the tomb's environment and its visitor management. With the help of an informed and appreciative public, we pledge our best efforts to that task.

May the tomb of Nefertari yet endure for all eternity.

Neville Agnew
Associate Director, Programs
The Getty Conservation Institute

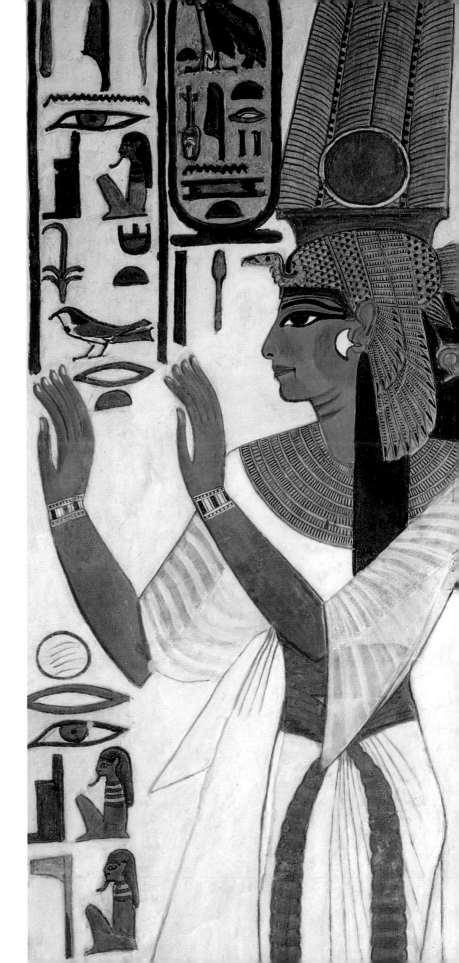

Nefertari on the west wall, south side of Chamber G.

Acknowledgments

This publication is the result of an exceptional team effort by the staffs of the Getty Conservation Institute, the J. Paul Getty Museum, and our consultants. The conservation of the wall paintings in the tomb took over six years. When the Supreme Council of Antiquities of Egypt decided to open to tomb to visitors, we felt it very important to contribute to a wider understanding of the significance of the tomb by those able to visit it as well as those who do not have the opportunity but still are interested in the subject.

John McDonald wrote the text, based on his extensive knowledge of ancient Egypt and of the tomb itself after a memorable visit with Getty staff. John Farrell edited the manuscript, structuring many parts to suit both the images and the organization of the book, and making the scholarly language of the text accessible to all readers. Neville Agnew, of the Getty Conservation Institute, supervised the book from start to finish and contributed his knowledge of conservation and of the tomb through invaluable suggestions. Chris Hudson, of the J. Paul Getty Museum, undertook this project with exceptional enthusiasm and superb professional skills. We are indebted to Mr. Hudson for his tenacity, vision, and focus.

Everyone will be able to better appreciate the beauty of the tomb thanks to the images produced mostly by Guillermo Aldana over his many years as photographer with the conservation team. The superb design comes from Vickie Karten who understands the needs for visual impact, aesthetics, and harmony. The publication would not have been at all possible were it not for Anita Keys who has relentlessly seen to it that photos, copy, production, and a myriad details all come together at the right time. Her perseverance is equaled by her good humor under pressure, creativity, and inventive management skills.

To all of them we are indebted.

Miguel Angel Corzo
Director
The Getty Conservation Institute

**Conservation of the Wall Paintings
Project Members 1986–1992**

Executive Body
Mohamed Ibrahim Bakr
Chairman
Egyptian Antiquities
Organization

Miguel Angel Corzo
Director
The Getty Conservation
Institute

The late Ahmed Kadry
Former Chairman
Egyptian Antiquities
Organization

Luis Monreal
Former Director
The Getty Conservation
Institute

Gamal Moukhtar
Former Chairman
Egyptian Antiquities
Organization

The late Sayed Tawfik
Former Chairman
Egyptian Antiquities
Organization

Conservation Team
Paolo Mora and
Laura Sbordoni Mora
Abd el-Rady Abd el-
Moniem
Abd el-Nasser Ahmed
Giorgio Capriotti
Luigi de Cesaris
Lorenzo D'Alessandro
Adamo Franco
Giuseppi Giordano
Ahmed-Ali Hussein
Lutfi Khaled
Adriano Luzi
Gamal Mahgoub
Hussein Mohamed-Ali
Paolo Pastorello
Stephen Rickerby
Sayed A. el-Shahat
Christina Vazio

Scientific Team
Farrag Abd el-
Mouttaleb
Nabil Abd el-Samia
Neville Agnew
Mokhtar S. Ammar
Hideo Arai
Omar el-Arini
Motawe Balbouch
Kamal Barakat
Farouk el-Baz
Asmaa A. el-Deeb
Eric Doehne
Michelle Derrick
Feisal A. H. Esmael
Gaballa A. Gaballa
Essam H. Ghanem
H. A. Hamroush
B. Issawi
Po-Ming Lin
Shin Maekawa
Modesto Montoto
Shawki Nakla
Antoni Palet
Eduardo Porta
Frank Preusser
Saleh A. Saleh
Michael Schilling
Wafa Seddia

Photographer
Guillermo Aldana

**Research:
Art and History**
Maḥasti Afshar

**Administration and
Management**
Ahmed Abd el-Rady
Salah Bayoumy Basyoz
Sayed Hegazy
Mary Helmy
Romany Helmy
Talat Mohrem
Mohamed Nasr
Eduardo Porta
Mahmoud Sadeq
Laura Sanders
Inée Yang Slaughter
Mohamed el-Sougayar

Ferryman
Farouk Fawey el-Daewy